PHOTOGRAPHY

The 50 most influential photographers in the world

First published in Great Britain in 2009

A & C Black Publishers Ltd
36 Soho Square
London W1D 3QY
www.acblack.com

ISBN: 978 1 408 10944 1

Conceived and produced by
Elwin Street Limited
144 Liverpool Road
London N1 1LA
United Kingdom
www.elwinstreet.com

Design: Diana Sullada
Picture credits: Corbis: pp. 27, 33, 41, 43, 50, 53, 55, 59, 65, 71, 73, 81, 89, 101, 103, 107, 117, 121, 125, 127; Getty Images: pp. 35, 63, 79, 87, 99, 119; Magnum: p. 109; Science and Society Picture Library: pp. 8, 13, 15, 17, 19, 21, 25, 57, 85, 113; Courtesy Sonnabend Gallery: p. 93; Stephen Shore / Gallery Stock: p. 97; Fraenkel Gallery: pp. 46 (© Lee Friedlander, courtesy Fraenkel Gallery, San Francisco), 95 (© Robert Adams, courtesy Fraenkel Gallery, SF and Matthew Marks Gallery, NY), 111 (© The Estate of Garry Winogrand, courtesy Fraenkel Gallery, San Francisco); Time & Life Pictures/Getty Images: 29; Ernst Haas/Getty Images: 38; Yousef Karsh/Rex Features: 61; Annie Leibovitz/Rex Features: 69; Sipa Press/Rex Features: 77; The Advertising Archives/Irving Penn: 75; RIA Novosti/Alamy: 123; Untitled (#70), color photograph, 16 x 24", Courtesy of the Artist (Cindy Sherman) and Metro Pictures: 127.

A CIP catalogue record for this book is available from the British Library.

Printed in Singapore

PHOTOGRAPHY

The 50 most influential photographers in the world

CHRIS DICKIE

CONTENTS

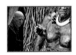
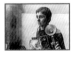

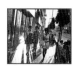
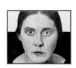

INTRODUCTION

As cultural media go, photography is a relative newcomer: just 170 years old. Yet it is ubiquitous. As long as 2,500 years ago, aspects of optical principles were understood and described, but it was well into the nineteenth century before someone managed to devise a way of capturing a permanent image created by focused light; and then, within days of each other, two of photography's pioneers made public announcements of their inventions, conceived independently on either side of the English Channel.

Photography was born. Without it there would be no films or television and, while the Internet might still exist, it would be a pretty dull place. The inventors of photography were scientists and businessmen, its early practitioners gentlemen hobbyists and tradesmen; now we are all photographers and the world is awash with images, as are the networks that now connect it.

An early application of the new art/science of photography was portraiture: painters saw their livelihoods under threat. But before long it had spread into myriad genres: topography and landscape, documentary and photojournalism, science and research, art and illustration, advertising and fashion, social portraiture and weddings. No area in which an image played a role was untouched, and with the invention of the snapshot camera the medium became democratised.

'If a day goes by without my doing something related to photography, it's as though I've neglected something essential to my existence, as though I had forgotten to wake up.'

Richard Avedon

The figures and innovations that feature in this book illustrate the range and diversity of the photographic medium as we now appreciate it and as it has evolved over time. The list is not exhaustive nor is it definitive, but without exception the individual photographers, artists, inventors and entrepreneurs featured here have each made their mark on photography's history, serving as inspiration to those who followed or, in the case of the inventors, facilitating new forms of photographic practice. These individuals are often described within the fields for which they are best known, but for many their influence is more wide-ranging. The fact is that these people resist categorisation: a social documentary photographer may make landscape studies and, in doing so, create art; any attempt to pigeonhole such practitioners is hopeless.

An essential quality of the photograph is its value as a document: we tend to trust what it shows us, or that, at least, is our starting position. So it is that photography plays its role in fields as diametrically opposed as forensics and propaganda, each image worth a thousand words. Early photography recorded ghosts and ectoplasm, but now we are more sceptical – the age of the digital image has seen to that. Yet the power of the photograph remains: the impossible perfection of the computer-enhanced model still prompts eating disorders in susceptible young women. We know the camera can be made to lie, yet prefer to believe it and approve the result.

Photographic images surround us and filter the way we perceive the world – even the stars, moon and other planets. They are how we remember our lives and gain understanding of the lives of others; they speak to us.

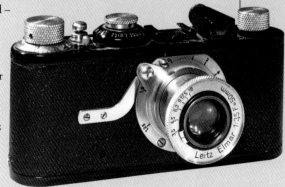

Louis Jacques Mandé Daguerre

Through collaboration with another Frenchman, also researching in the field of image capture, Louis Jacques Mandé Daguerre devised a way of fixing a permanent positive image on a metal plate. This was the first photographic process that enjoyed widespread application.

Born 1787, Cormeilles, France
Importance Invented the first viable photographic process to be announced to the world
Died 1851, Bry-sur-Marne, France

Daguerre trained as a theatre set painter and designer in his early 20s, assisting Pierre Prévost in Paris. From 1814 until 1818, he was head set painter for L'Ambigu-Comique and subsequently L'Opéra. His sets were so striking that his design talents had the reputation of being able to carry a show on their own.

He established his own business and opened his 'diorama' in Paris in 1822. Combining strikingly realistic painted landscapes with the skilful use of lighting, the breathtaking spectacle was an overnight sensation.

Daguerre's interest in using optical techniques to produce

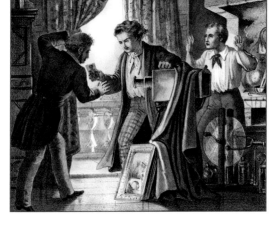

A chromo-lithograph of Daguerre demonstrating the new process to Niépce's nephew, c.1851.

these lifelike paintings attracted him to the work of Joseph-Nicéphore Niépce, who was seeking to perfect a process he called heliography. This was the earliest known photographic process and captured an image using technology based on lithographic printing. In 1829, Niépce and Daguerre formed a partnership to continue the research and exploit it commercially, but the older Niépce died, in 1833, before this had been achieved. Daguerre continued the research alone, working on a different process, in which he used mercury vapour to develop a latent image formed on a silver plate. Further research had shown that the plate could be sensitised to light by exposure to iodine vapour, producing a plate that required much shorter exposure times. (Niépce's heliographs had required exposures of several days.) But there was still a problem: the developed image was fugitive; almost as soon as it was there it was gone. Yet further research proved that the image could be 'fixed', with some success, using a solution of common salt. It was 1837 and a practical procedure he named the daguerreotype had been achieved.

DIORAMA
A staged lighting effect in which several translucent paintings are placed one behind the other and lit in sequence. The effect is to create the optical illusion of a changing scene. Dioramas are still commonly seen in three-dimensional museum displays of historical scenes and events.

The new process produced a positive image that was a one-off, and yet Daguerre failed to profit from it. He sought assistance from the eminent physicist François Arago who, on 7 January 1839, announced Daguerre's process to the French Academy of Sciences. Although he did so without giving away precise details of the process, the news was a sensation.

Six months later, the king of France, Louis Philippe, signed a statute on behalf of the government buying the process from Daguerre in return for an annuity of 6,000 francs; Niépce's son and heir, Isidore, received 4,000 francs a year. The daguerreotype process was made public and enjoyed a period of success, particularly in the making of portraits, many of which still survive today.

THE BIRTH OF
PHOTOGRAPHY

**The concept of the pinhole camera dates back as far as 400 BC.
The first version of the camera obscura (Latin for 'dark
chamber') was built as long ago as 1000 AD; but it was not
until the mid-eighteenth century that photography as we
know it was invented. Then, only 50 years later, the first
'snapshot' camera brought photography to the masses.**

In 1826, Frenchman Joseph Nicéphore Niépce, experimenting
with the newly invented lithographic printing process, made
what is considered to be the first permanent photograph. He coated a
pewter plate with a light-sensitive varnish of his own devising and
successfully contact-printed an engraving onto it. He called this a
'heliograph', or 'sun drawing'.

At the same time, Louis Daguerre was experimenting with image
production for the dioramas he was showing in Paris. His
daguerreotype process was announced to the French Academy of
Sciences in January 1839, wherein a polished silver plate was made
light sensitive by exposure to iodine fumes and then exposed in a
camera. The daguerreotype was developed in mercury vapour,
producing a one-off positive image when viewed at the correct angle.

Meanwhile, during the mid-1830s in England, William Henry
Fox Talbot had discovered that writing paper treated with a solution
of common salt and sensitised with silver nitrate became light
sensitive, darkening on exposure to daylight. By making contact
prints of lace and leaves, he created what he called 'photogenic
drawings', and later went on to make exposures in-camera. He
announced his invention at the Royal Institution in London in the
same month that the daguerreotype had been heralded in Paris and,

after some refinement, named the process the 'calotype'. By involving the production of a negative, from which an unlimited number of positive copies could be made, Talbot's idea was the forerunner of all the commercially successful processes that were to follow.

It was Talbot's contemporary, Sir John Herschel, who first identified the importance of the negative/positive process and who came up with the use of sodium thiosulphate to 'fix' the image and make it permanent.

> *'From today, painting is dead.'*
>
> French artist Eugène Delacroix, on seeing a daguerreotype portrait

Thereafter, many ways to produce negatives, and make prints from them, were developed, mostly involving sensitised glass plates. Yet the plates' sensitivity to light was poor, involving long exposure times, and the cameras were bulky.

The American, George Eastman, was determined to simplify photography and, in 1888, came up with an invention that was to revolutionise the medium – the first Kodak camera. Eastman's Kodak was small and light, easily hand-held and simple to operate. It contained a roll of paper-based 'film', long enough for 100 exposures, which was wound on between shots using a key. The shutter was cocked by pulling a cord and there was a button to press to release it. When all 100 exposures had been made, the camera was sent to Eastman's company where the film was developed and prints made. The camera was then reloaded and returned to the customer. Less than 50 years after the public announcement of photography, the snapshot had been born.

William Henry Fox Talbot

At the same time as Frenchmen Niépce and Daguerre were experimenting with early techniques of image capture, the English gentleman and scientist, William Henry Fox Talbot, was researching the same field, but via a different route. And although Daguerre was the first to announce his process to the world, it was Talbot's invention that was to form the basis of all photography up until the introduction of electronic imaging.

Born 1800, Melbury Abbas, England
Importance Originated the process on which all subsequent photography was to be based
Died 1877, Laycock Abbey, England

In 1934, Talbot invented the salted paper print. He impregnated writing paper by coating it, first with common salt and, after drying, with a coat of silver nitrate. This formed silver chloride on the paper's surface, which proved to be more sensitive to light than silver nitrate. This 'salted' paper allowed him to make camera-less images of botanical specimens and other objects, such as lace. He achieved this through contact printing, which produced a negative version of the original. The coated paper simply darkened on exposure to light, so forming the image without the need for development. Talbot could then make a positive image by contact-printing the negative, although his materials did not yet produce a result of acceptable density or detail. He increased the sensitivity of the paper through repeated coatings and experimented with small cameras to make negatives.

In 1839, the success of the daguerreotype process in France

'How charming it would be if it were possible to cause these natural images to imprint themselves durably, and remain fixed upon the paper!'

gave Talbot fresh impetus. At this stage, daguerreotypes appeared to have the brighter future, as the images were much more refined and detailed than salt prints. However, Talbot discovered that, by using iodised paper and brushing it with gallic acid after exposure, the 'latent' image was 'developed' and a negative produced. A positive could then be made by contact-printing on to salted paper. He called this new process the 'calotype' (from the Greek for 'beautiful print'), and patented it in 1841.

Talbot's work was greatly assisted by the astronomer and chemist, Sir John Herschel, who advised Talbot that, by waxing the paper negative, its improved transparency would aid production of a superior positive print. Most importantly, Herschel had discovered that sodium thiosulphate (hypo) would dissolve silver salts and so could be used to remove the undeveloped silver halide from the printing rendering it permanent.

> **CONTACT PRINTING**
> Making a print by exposing photosensitive paper to light through a negative held in close contact with it, rather than by projecting the image through an enlarger.

Thus were established the principles from which all photography would follow: a scene is focused and exposed onto light-sensitive material in a camera and a latent image formed, which is then chemically developed. The resulting 'negative' can then be used to make countless identical 'positive' prints. It is for that reason, in particular, that Talbot is widely considered to be the father of photography.

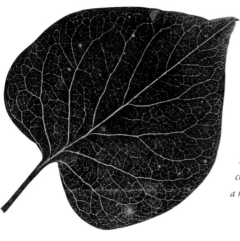

A salted paper print, contact-printed from a negative of a leaf.

Eadweard Muybridge

The long exposure times required by early photographic materials meant that movement of the subject was recorded as a blur. It was not long, however, before the light sensitivity of the process improved and mechanical shutters were developed so that 'instantaneous' exposures – measured in fractions of a second – became possible. With instantaneous exposure came the ability to 'freeze' the subject , a facility exploited by Eadweard Muybridge.

Born 1830, Kingston-upon-Thames, England
Importance Applied photography to reveal what the eye could not normally see
Died 1904, Kingston-upon-Thames, England

Eadweard James Muggeridge was born just outside London. His pseudonym was his idea of the Anglo Saxon version of his name, his birthplace being associated with the crowning of Saxon kings. In 1852, then in his early 20s, he moved to North America, where he gained a reputation as a landscape photographer of the American West, in particular Yosemite.

In the early 1870s, Muybridge picked up on the work of French physiologist Etienne Marey, who had been using photography to study animal and human movement in the 1860s. He was commissioned by the former governor of California and racehorse owner, Leland Stanford, to help settle an argument as to whether or not a horse has all four feet simultaneously off the ground when galloping, as Stanford believed was the case. Although, by now, the necessary short exposure times were possible, it still took Muybridge a while to work out how to tackle the problem. To minimise exposure time while capturing a clear image, he built a white runway to photograph against and set up a barrage of 12 stereoscopic cameras along it, to be fired by tripwires across the runway as the horse, named Occident, galloped past. Remarkably, it worked, and proved

Stanford to be right. The results showed what the eye was unable to perceive unaided and they disproved the traditional representation by artists of what had been taken for granted.

As well as the horse, Muybridge went on to study men and women walking, running and jumping. Some sample sequences were published in *Scientific American* magazine in 1878, along with an article that suggested readers try cutting them out and placing them in a 'zoetrope' so that the illusion of motion might be created. Intrigued by the idea himself, Muybridge experimented further, in time inventing the zoopraxiscope, which proved extremely popular, and was itself a forerunner of cine photography. Muybridge's report on the subject, 'Animal Locomotion', was published in 1887 and contains over 20,000 images. The pioneering work of Eadweard Muybridge is still referenced today in science and the arts. It inspired visionary works such as Duchamps' 'Nude Descending a Staircase' and presaged the film industry by a generation.

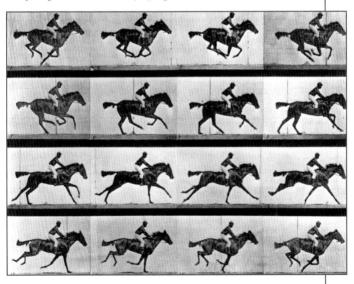

Muybridge published a book of photographs, The Horse in Motion, *in 1882.*

The Lumière Brothers

Auguste and Louis Lumière were the sons of successful portrait photographer, Antoine. Auguste worked with his father in the studio while Louis, who was a physics graduate, perfected a gelatin-silver-bromide dry plate, which was produced commercially by their factory. In 1907, the factory began to manufacture 'autochrome' plates, which became the mainstay of colour photography for almost 30 years.

Born (Auguste) 1862; (Louis) 1864, Besançon, France
Importance Invented the autochrome, the first viable colour photography process
Died (Louis) 1948, Bandol, France; (Auguste) 1954, Lyons, France

The first colour photograph had been made as early as 1861 by Scottish scientist, James Clerk Maxwell, using 'additive' colour, the theory being that, by mixing the three primary colours of red, green and blue in proportion, any colour could be reproduced. He made three separate black-and-white positives of a tartan ribbon, each exposed through colour filters which, when projected simultaneously, combined to produce a colour image of the original. In 1869, French scientist, Louis Ducos du Hauron, proposed a simpler method, employing a screen of fine rulings in the primary colours to produce the same result, but with one single exposure. Over the next 30 years, variations on this approach were suggested and patents taken out, but the complexity of the processes, and the instability of their images, meant that none were commercially viable.

The Lumières also researched colour processes and, in 1903, Louis' invention, the autochrome, was patented. The process

'Colour and photography do not belong together.'

American photographer Paul Strand, writing in 1917.

involved using a mosaic of microscopic potato starch grains, dyed in the primary colours and stuck to the surface of a glass plate. To refine the process the tiny gaps between the coloured grains were filled with a fine dusting of carbon black. This filter layer was protected by a layer of shellac and then coated with a newly developed panchromatic emulsion (one of

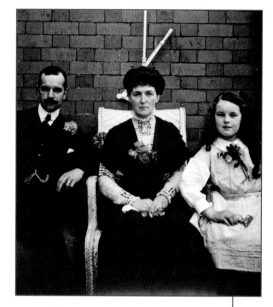

Although fragile, many autochromes survive, and can be very beautiful. This example, of a Victorian family, dates from 1910.

equal sensitivity to all wavelengths of light). The plate was exposed through the back so that the image-forming light passed through the coloured filter before reaching the emulsion. A reversal process involving development, re-exposure and redevelopment was used to create a positive image made up of tiny dots representing the primary colours and the images could be viewed by transmitted light or projection.

An autochrome image mimics that of reproductions of colour pictures in print and echoes the techniques of pointillist artists such as Seurat. Although the scientific imperative to achieve a viable way to photograph in colour is obvious, it was not until a good 60 years later that colour photography would be given the aesthetic stamp of approval by the majority of photographic artists.

George Eastman

When George Eastman developed an interest in photography he found the complexity of the process a serious bar to its enjoyment. The process of the day involved using wet plates that had to be coated just before use and exposed before they dried; Eastman experimented and successfully developed a dry plate, which he patented and, in 1880, he set up his own photographic business.

Born 1854, New York, United States
Importance Invented snapshot photography, bringing photography to the masses
Died 1932, New York, United States

After further experiment, in 1884, Eastman took out a patent on a photographic medium that was an alternative to the fragile glass plates: this was a paper roll coated with photo emulsion and had the advantage of allowing a camera to be loaded for multiple exposures. The democratisation of photography was complete when, in 1888, Eastman lodged a patent for a camera designed to use his roll film and registered the trademark 'Kodak'.

Kodak photography was easy. The camera came pre-loaded with sufficient paper film for 100 exposures and, when completed, the entire camera was returned to the Eastman factory. Here the camera was reloaded and returned to the owner. The exposed roll was then developed and printed. The Kodak was a million miles from the camera equipment that preceded it: it was small, light and portable, and extremely simple to use. The introduction of transparent film, in 1891, further improved the quality of the results and also allowed photographers to do their own processing should they wish to.

George Eastman's mission to bring photography to the masses continued with the introduction of

'You Press The Button – We Do The Rest.'

Kodak advertising slogan

the Brownie camera, in 1900. The original Kodak had cost $25 and so was a relative luxury, but the Brownie sold for only $1 and was a great success. Before Eastman's intervention, photography had been limited to a middle class hobby and profession, demanding a certain investment of time, money and training. His cameras opened the market to a much broader cross section of society and the ease and speed with which pictures could be made introduced the idea of the 'snapshot' to the medium. Remarkably, the word 'snapshot' – a term adopted from hunting jargon – was coined by Sir John Herschel way back in 1860, when speculating how the future of photography might evolve.

In time the company grew to be the biggest manufacturer of film and printing papers in the world, with a huge range of products for every application, and offering a range of snapshot cameras. Eastman gave up his executive duties in 1925, but remained a member of the board.

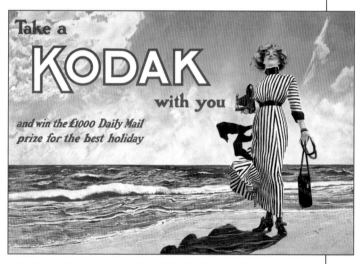

The 'Kodak Girl' became central to the firm's advertising from 1910, epitomising the wider audience now using snapshot cameras.

Edwin Land

While George Eastman can be credited with the invention of snapshot photography in the 1880s, it was Edwin Land who took this to its ultimate conclusion, in developing a camera system that would produce 'instant' photographs.

Born 1909, Connecticut, United States
Importance A workaholic research scientist whose inventions included polarising sunglasses and instant snapshot prints
Died 1991, Massachusetts, United States

Land entered the imaging business through his research into polarising materials. The principle of light polarisation was well understood and had many applications; yet there was no known way of producing such materials economically. Land's breakthrough was to devise a way to make a sheet film containing millions of microscopic polarising crystals, which, in the manufacturing process were made to align with each other, so extending their polarising quality to the entire sheet. In 1932, he set up a commercial laboratory to exploit this research with his physics tutor from Harvard which, in 1937, became the Polaroid Corporation.

Land's invention of the 'instant' camera was in response to his young daughter wondering why she couldn't immediately see the snapshots he would make of her. In 1947, he demonstrated the first instant camera system: it used unique film packs, a roll of negative paper and one for the positive print which carried pods of the developing agent. After exposure, development took place in the camera: the negative and positive were squeezed together with the reagent sandwiched between them, and the image transferred from one to the other via the process of diffusion transfer. After a minute, the two were peeled apart and a sepia print revealed. The Land camera went on sale at a Boston department store in the run-up to Christmas 1948. Customers were so impressed that the entire initial production run of 57 cameras and film sold on the first day.

Polacolor film introduced colour to instant photography in 1963 and, over the years, many different camera models appeared – some snapshot, others for professional and scientific applications. In the mid-1970s, Kodak came out with a competitor, but the patent lawyers made sure the competition was short-lived; Fuji was later and more fortunate: the company still produces an instant-film product for professional use.

Indeed Polaroid's instant-print products were essential tools of the trade among professionals for many years, in particular studio photographers wishing to check lighting setups before committing the shot to film. For the professional, the relatively high cost per print was easily offset against the time and money saved; and, despite the high cost, mass-market demand held up through a combination of the appeal of the instant snapshot and the fact that Polaroid had a monopoly. Until, that is, digital photography came along, with even quicker results and no film costs at all.

In developing a system that produced instantly viewable results, Edwin Land continued the popularisation of photography that George Eastman had begun with the original Kodak camera.

POLARISATION
In nature, light waves oscillate in all directions, and a polarising material, or filter, works by limiting the light passing through to oscillation in a single plane. This reduces brightness, eliminates glare and increases colour saturation. Applications for such materials range from sunglasses, to photographic filters, to liquid crystal displays.

Land's first commercially produced Polaroid camera, the Model 95, manufactured from 1948 to 1953.

FROM FILM TO DIGITAL

For 160 years, the negative/positive process, invented in the eighteenth century, remained the essence of how photographs were made. Films and cameras constantly improved, but the process at the heart of the matter remained essentially the same. Then, as a new century dawned, film photography was pushed into the back seat by the digital image.

The beauty of the photographic process invented by William Henry Fox Talbot in 1839 was that it produced a negative from which any number of 'positive' prints could be made. With the introduction of the Kodak snapshot camera the hitherto complex business of photography was greatly simplified and made available to anyone. Photography became a popular pastime, either simply for recording memories, or as a more serious hobby. The adoption of the so-called 'miniature' film format as a standard (35mm) made for small, portable, cameras, and by the 1960s the widespread availability of affordable single-lens reflex (SLR) cameras encouraged many to take up the hobby. Given the right equipment, black-and-white film was easy to develop, and the home darkroom prospered.

By the mid-1980s, with the introduction of inexpensive 'compact' cameras with automatic exposure and focusing, and the availability of cheap colour processing and printing, plenty of photographs were still being taken, but the home darkroom was in decline. New technologies – hi-fi, computer games and video cameras – were competing for the public's disposable income. At this time, the first consumer electronic cameras came, using technology derived from camcorders to capture a still image. The technology was clever, but the image quality was poor: what viewers were used to as a moving picture on a television screen did not stand up to scrutiny as a

single freeze frame. The image was made up of lines, something you don't notice when the image is moving. Then came digital.

With computers and colour monitors becoming commonplace at work and in the home, the scene was set for imaging technology that would exploit them. Microchips were developed that were able to convert light into electronic data, converting the intensity and colour of the light into a set of numbers or digits – hence 'digital'. The chips were divided up into thousands (now millions) of discrete picture elements or 'pixels', each capable of recording the value of the light falling on it. By storing the data in a way that it could be read back in the correct order and displayed on a monitor, even printed out, the digital image had been born.

These chips, with their myriad pixels, were extremely expensive to make and, initially, of such low resolution that it seemed unlikely they would threaten the ability of film to capture and store information readily and cheaply. But within a short time improvements in technology ensured the ubiquity of the digital snapshot. Photography as an activity enjoyed a huge renaissance.

Digital photography involves little expense beyond the initial outlay: you view the results immediately and, if you don't like it, wipe it. Images can be swapped easily using mobile communication, email and the Internet. Whole image-based communities have blossomed on the web. High-quality inkjet printers are available at unbelievably low prices: a combination of slick technology and the makers knowing they will make their profits on the ink and paper consumed.

After 160 years of relative stasis, photography has become universal and democratised through the combining of complementary technologies.

> 'I have always taken photography seriously, and the magic of photography, regardless of the camera, lens, developer or computer chip, I will always consider serious magic.'
>
> Joe DiMaggio

Mathew Brady

Mathew Brady, and the photographers under his supervision, documented the American Civil War, earning him the tag 'father of photojournalism'. But the scale of the enterprise was to break him financially.

Born 1822, Warren County, United States
Importance Famed for his portraits of nineteenth-century celebrities and his documentation of the American Civil War
Died 1896, New York, United States

Brady was born to Irish immigrant parents and moved to New York at the age of 17. By the time he was 23, he owned his own portrait studio and was exhibiting his daguerreotypes of famous Americans. In 1849, he opened a studio in Washington; it was a profitable time for portrait studios and the small portrait prints, known as *cartes de visites*, were extremely popular.

When the American Civil War broke out, in 1861, photography was only just over 20 years old, but had evolved to the point where large glass negatives were being used, from which multiple prints could be made. Brady saw the war as an opportunity for sales of souvenir pictures of heroic men in uniform, and organised photographers to work in the field, accompanied by mobile darkrooms. Three months into the war Brady, and photographer Timothy H O'Sullivan, took up position above the Bull Run battlefield, expecting to record a great Union victory: in the event it turned into an ignominious retreat. Brady claimed to have made photographs of the battle but that they had been lost in the flight: he himself vanished for three days and reappeared in Washington weak with hunger. He made few battlefield visits thereafter, perhaps because of his failing eyesight, and spent the rest of the war running his New York studio, from where he supervised up to 20 units of photographers in the field. The agreement was that their photographs would go under his name as employer.

The collodion process used by photographers of the day was not conducive to action pictures, so many of the photographs portrayed still subjects, in particular body-strewn battlefields. And, being made from large negatives, the details were evident. While the work was admired, its terrible reality was too honest for many. The country had expected the war to be short-lived, but it lasted four years, by which time the populace was thoroughly tired of it and, far from wishing to buy photographic souvenirs, wanted to forget.

Roger Fenton had been the first to photograph war, in the Crimea a few years earlier, but his work was largely propagandist and he made pictures he knew he could sell. The work of Brady and his photographers, by contrast, showed war as it really was, which is why he takes the title of 'father' of photojournalism.

Brady made portraits of senior officers on both sides, including such famous names as Grant, Custer, Lee and Jackson. By the end of the Civil War it is said that he had invested $100,000 in photographing it, and had made little of it back. In 1875, Congress bought his archive at auction for $2,840 and, although he was granted $25,000 in recognition of his enterprise, its vast cost had completely bankrupted him. Brady had been the first to use photography to show the truth of war, but at a cost.

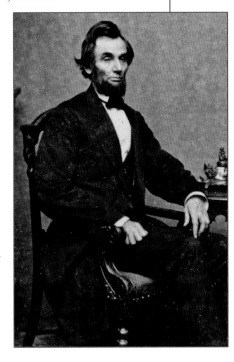

A carte-de-visite portrait of American President Abraham Lincoln, 1863, from a negative made by Brady.

Weegee

News photographer, Weegee, made his name through a combination of shameless self-promotion and an uncanny knack of being the first person at the scene of the crime. His images of the city streets and crime scenes at night came to define the rough and raucous New York of the 1930s.

Born 1899, Zioczew, Austrian-Gallicia (now Ukraine)
Importance Carved a unique niche, photographing New York by night
Died 1968, New York, United States

Born Usher Fellig, Weegee changed his name to Arthur at the age of 10 when, fleeing from anti-Semitism, his family moved to New York. It's not clear who gave him the nickname Weegee – Fellig himself, one of the Acme photo agency staff with whom he worked, or a police officer – but it comes from the New Yorker's pronunciation of ouija, a reference to his eerie ability to be among the first at the scene of a news incident.

Of course, he had no supernatural powers. Instead, Weegee held a shortwave radio licence and would sit in his Chevrolet listening to police broadcasts. He was also unique in being allowed to work out of the Manhattan police headquarters. His car had a darkroom installed in its boot to give him a further edge in being the first to get pictures to the newspapers. Weegee adopted a 'foolproof' routine for photographing difficult circumstances and scenes in the dark. His camera was a 5 x 4in Speed Graphic, the standard tool of the press photographer; exposure was by flashbulb, and he used a small lens aperture with preset focus to give maximum depth of field and sharpness. When making the picture, all that was required was to quickly frame the scene and release the shutter. This approach gave Weegee's pictures a consistent, recognisable feel and expressionistic style and he would send them to the papers credited to 'Weegee the Famous'.

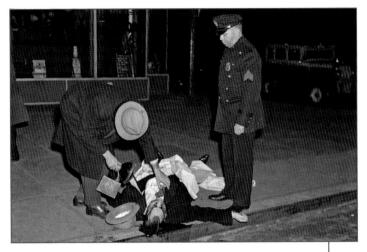

The murder scene of David 'the Beetle' Beadle in Manhattan.

Weegee photographed murdered gangsters and violence within families, car crashes and knocked-down pedestrians, backstage strippers and bar life in the rougher parts of town, tramps, grotesques and opera-goers. His pictures recorded the edginess, danger, violence and tragedy – literally the darkness – of the city by night. Weegee's photographs of New York were collected together for his first book, *Naked City*, published in 1945. It became the inspiration for the 1948 movie of the same name, and the title was later adopted by a television detective series.

From 1947 until the early 1960s, Weegee worked in Hollywood as a photographic consultant, technician and stills photographer; he even worked as an actor. In 1953 *Naked Hollywood* was published. In his later years he experimented with caricatures of celebrities, photographed through distorting mirrors: Vice President Richard Nixon and Marilyn Monroe were among his 'victims'.

To an extent Weegee was famous for being famous, something he saw to personally. Yet his unique approach to his job, and his prodigious output in a striking and singular style, have marked him out as the greatest crime photographer of all time. Even if he said so himself.

Margaret Bourke-White

Margaret Bourke-White's father was an engineer and inventor and her mother a resourceful homemaker. Between them, they instilled in their daughter a deep desire for self-improvement. This determination saw her excel in the exclusively male field of photojournalism and war reportage.

Born 1904, New York, United States
Importance A relentless pursuer of pictures and the first woman in a man's world
Died 1971, Connecticut, United States

Bourke-White studied photography under Clarence White, whose school was unique in the United States in being the only one devoted to teaching art photography and the principles of modernism. She began work as an industrial photographer, producing a significant body of work for the Otis Steel Company in Ohio in the late 1920s. Her work came to the attention of publisher Henry Luce and, in 1930, he hired her to photograph for *Fortune* magazine, whose pages showcased the grandeur of industry and technology.

Luce also set up *Life* magazine and Bourke-White provided the cover shot for the launch issue. At this time she was setting the pace for industrial photography in the United States: she had been the first Westerner allowed into the Soviet Union to photograph.

During the Great Depression, she switched her attention to photojournalism, and in 1935 she documented a worker's family for *Fortune*. The following year she collaborated with the writer Erskine Caldwell on an FSA project (see page 48), a book of words and pictures on Southern poverty titled *You Have Seen Their Faces*. The pair were married in 1939, but divorced

'I feel that utter truth is essential and to get that truth may take a lot of searching and long hours.'

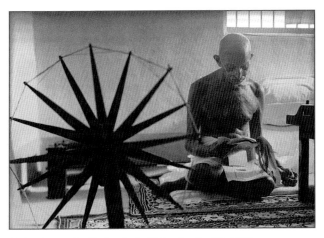

An iconic portrait of Indian leader Mohandas Gandhi, 1946.

in 1942; despite two marriages she never had any children.

Bourke-White had a firm belief in the camera's ability to preserve democracy and photographed in Czechoslovakia, Germany and Austria during the rises of Communism and Nazism. In 1941, she and her husband travelled to Moscow in the belief that the war might spread there: when the Germans broke their non-aggression pact with Russia and invaded, she was the only foreign photographer in the city and became the first-ever female war correspondent.

In 1943, Bourke-White became the first woman to fly on an American bombing mission in an attack on Tunis airport. In 1945, she accompanied General Patton through Germany in the final stages of the war and recorded the liberation of concentration camps at Buchenwald and Erla and the dreadful sights that awaited the Allied forces. She also photographed the suicides of German officials and ordinary families, panicked by the advancing victors.

Whether by accident or design, Margaret Bourke-White's success as a photojournalist came, in part, from being in the right place at the right time (she interviewed and photographed Gandhi hours before his assassination). And her persistence, compassion and talent ensured she was a woman of many firsts.

THE CAMERA AT WAR

From its earliest days, photography has sought to depict the horror – and sometimes the glory – of war. The documentary evidence provided by a photograph was considered a powerful argument in its favour as a more objective means of describing events than eyewitness accounts. But early war photography fell short of expectations.

The Crimean and American Civil Wars were the first to be photographed, although the technology of the day was not up to the job. The action shot was not an option: cameras were cumbersome and long exposure times made photographing a moving subject impossible. These early war photographs tended to concentrate on the aftermath: scarred battlefields strewn with debris and dead combatants. Conversely, they might feature soldiers and fortifications before battle ensued, carefully holding the pose. Neither option really captured the truth of war, which negated the documentary strength of the new medium. More to the point, photographing the aftermath, with no decisive moment to capture, led to the questionable practice of rearranging elements within the frame for aesthetic effect before the photograph was taken; so much for the objective truth.

Propaganda is an important weapon in wartime, and photography has played its part in promoting a positive image to the folks back home and a negative one to the enemy. Yet, by the second half of the twentieth century things had changed. By then, the role of the photojournalist was established, with the photographer not only

> *'War is like an aging actress: more and more dangerous and less and less photogenic.'*
>
> Robert Capa

providing images, but detailed captions for context. The ubiquitous 35mm single-lens reflex (SLR) cameras were small and light and took 36 frames before needing to be reloaded. The photographer was equipped for war as never before.

Photojournalists had a long-held belief that photography could be used to change opinion; many saw their role not simply as documenting events, but as agents of change. It is not easy to gauge to what extent this was correct, but the involvement of US forces in the war in Vietnam provides a case in point. From 1965, the US deployed forces in the arena in an attempt to prevent a communist takeover of South Vietnam. This was a deeply unpopular action. The Second World War was well within living memory and the American public had little sympathy for its troops being sent into conflict on the other side of the world. The role of the media did not work in the favour of the authorities.

Not only were the photographers in Vietnam well equipped to report the reality of the war, but the communication networks were in place to distribute their images rapidly and globally. The war held the daily news agenda and, as each new story broke and each shocking image surfaced, public resentment of US involvement in the conflict strengthened. The anti-war movement in the US grew into a lobby so powerful that it could not be ignored.

Photography played a major part in ending US military involvement in Vietnam and produced iconic images that have taken their place in history. Photographers including Don McCullin, Tim Page and Philip Jones Griffiths produced powerful bodies of work in dreadfully hazardous circumstances: McCullin was saved from a bullet by the body of the Nikon slung around his neck; Page suffered a severe shrapnel wound to the head and never fully recovered.

Prime examples of images that turned opinion include Nick Ut's photograph of a naked girl fleeing a napalm attack and Eddie Adam's picture of a police chief executing a Viet Cong prisoner. The power of photography to undermine a government's intent was proven – and it would never be allowed to happen again.

Robert Capa

Co-founder of Magnum Photos – a cooperative agency set up to represent the work of its members, protect their rights and share income among them – Robert Capa espoused freedom and sought to denounce war through his photography.

Born 1913, Budapest, Hungary
Importance Author of many iconic images of the Second World War
Died 1954, Thai-Binh, Vietnam

Capa was born Endre Erno Friedmann to Jewish parents in Budapest in 1913. He began making photographs in 1930 and, the following year, settled in Berlin, where he began a career with the Dephot picture agency. In 1933 he fled the Nazi regime and moved to Paris. Here, he adopted a subtle name change to André Friedmann.

In Paris he met, and teamed up with, Gerda Taro, a 20-year old German student, photographer and anti-fascist; they became lovers. Friedmann's work was represented by the Alliance Photo Agency, and he and Taro between them invented the 'famous' Amercian photographer 'Robert Capa' as a vehicle for his photos.

Capa became a news photographer and his pictures of the Spanish Civil War were published regularly in French, British and American magazines from 1936. In 1937, his partner Taro was killed in Spain during a Francoist attack. The following year Capa became famous when his photograph, 'Death of a Republican Soldier', was published in *Vu* magazine in France. It's a picture that remains controversial to this day, with arguments over whether or not it really shows a soldier at the point of death, unresolved. The debate continues to the extent that it is now more often referred to as 'The Falling Soldier'. That same year, Capa travelled to China to cover the Sino-Japanese war and, in 1939, he emigrated to America, settling in New York.

Capa's most famous picture series was taken while on an assignment for *Life* magazine during the Second World War. He

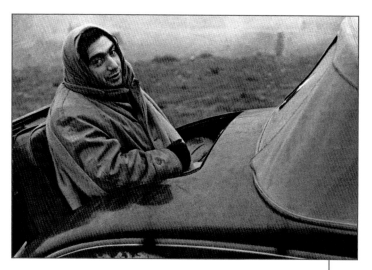

Typically fearless, Robert Capa travels in the boot of a car on the way to a news story.

photographed American troops landing at Omaha beach in the Allied D-Day invasions of Normandy, 6 June 1944. Taking two cameras, he photographed for an hour and a half under German fire, lying in the sea and in the sand. His films reached the magazine's London office the following evening, just before the issue was due to go to press. Aware of the urgency, the darkroom technician processed the images and cranked up the heat on the drying cabinet to get them ready for the picture editor. He overdid it: the excessive heat melted the film's emulsion and only eight barely printable frames survived. However, the exaggerated graininess of the images caused by reticulation of the emulsion actually enhanced the drama and realism of the photographs; they became icons and passed into legend.

Capa formed Magnum Photos with Seymour, Cartier-Bresson and William Vandivert in 1947. Following his untimely death, in 1954, he was awarded the Croix de Guerre by the French army.

W Eugene Smith

At the age of 15, Eugene Smith was selling photographs to local newspapers and had had a picture published in the *New York Times*. Before he was 30, he was working on assignments for *Life* magazine and was among the first photojournalists to challenge the autonomy of its editors.

Born 1918, Kansas, United States
Importance Master of the extended photojournalistic essay
Died 1978, Arizona, United States

Attending university on a photography scholarship, Smith dropped out after a year and moved to New York to become a full-time professional. He joined the Black Star agency and then, from 1939 to 1942, covered the Second World War for *Life* magazine in the Pacific arena.

He worked for *Life* from 1947 to 1955, on over 50 assignments. Smith's relationship with his editors was fraught: as author of the work he demanded his say in its editing and layout. The result was much antagonism and compromise, but the published stories were widely admired by the critics and the magazine's huge readership. In 1955, Smith resigned and joined Magnum Photos.

At Magnum, he worked on self-initiated projects, taking sole control of the editing and captioning. His first major assignment was a three-week commission to photograph Pittsburgh and provide Stefan Lorant, the former editor of *Picture Post*, with 100 prints for a book celebrating the city's bicentenary. The deadline passed and Smith continued to photograph Pittsburgh for a year, producing more than 13,000 negatives. The same editorial arguments ensued, resolved by Smith leaving Lorant with hundreds of prints to do with as he pleased.

He then embarked on an obsessive three-year labour of making work prints and creating layouts. He eventually finalised a set of about 600 to fine-print standard, but never saw his magnum opus realised in print. Both *Life* and *Look* magazines offered him fabulous

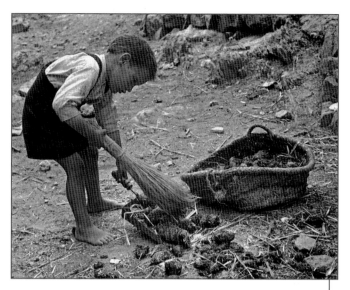

A young boy sweeping farm manure, from Smith's period with Life *magazine.*

sums for the work, but would not cede the editorial control that Smith demanded, so no deal was reached. In 1968, *Aperture* published a monograph of 120 of his pictures as a portfolio of his career: *W Eugene Smith: His Photographs and Notes.* Smith followed this with an exhibition of almost 650 prints under the title 'Let Truth Be Prejudice', which opened in New York in 1971 to great acclaim.

His most famous body of work was made in Japan between 1971 and 1975. He learned of a fishing village, Minamata, whose people had been poisoned by the dumping of mercury-contaminated waste into the bay. The toxic metal had entered the food chain, poisoning the locals, and causing dreadful congenital abnormalities in children. The most iconic image from the series is 'Tomoko Uemura in Her Bath', in which a mother baths her disabled child. The man-made tragedy is summarised in a single frame of dramatic chiaroscuro. Published in 1975, *Minamata* was the culmination of his life's work.

Eugene Smith's workaholism, coupled with alcohol abuse, brought his life to a premature end, and he died of a stroke, aged just 59.

Photojournalism

THE PICTURE ON A PAGE

Photography notably entered popular visual culture during the heyday of the picture magazines, the 1930s, a time when television had been invented but was yet to become commercially available. Two magazines in particular stand out, launched on either side of the Atlantic, in the years running up to the Second World War. Both were the product of visionary publishers, editors and photographers, and both achieved massive circulations.

The first was *Life*, launched in 1936 by Henry Luce. He had acquired the struggling title from its owners and revived it as the first US magazine to be based purely on photography. It was a runaway success, selling at its peak between 8.5 and 13.5 million copies each week, depending on which source you believe. Suffice it to say it was very successful, despite being launched in the middle of the Great Depression. *Life* featured picture stories promoting mainstream, middle-of-the-road American conservative values, and reflecting the political positions of the men behind it.

The photographers had little editorial control over their work, save for the choice of images they might submit for publication, but it published photography by many of the greatest talents: Henri Cartier-Bresson, Margaret Bourke-White, Eugene Smith, Robert Capa, Alfred Eisenstaedt … the list goes on. In the absence of television, the magazine brought the Second World War to the public at large, along with picture stories from all parts of the world, and was eagerly consumed.

In Britain, *Picture Post* appeared in 1938. Although it, too, published photojournalism with an agenda, it was more campaigning than its US counterpart, in no small measure because its founding editor, Stefan Lorant, and his initial photographic staff of two, Felix

Man and Kurt Hutton, were European refugees from the Nazis. From its inception, and throughout the war, the magazine railed against, and ridiculed, the enemy regime.

Whereas *Life* could be relied upon to take a generally right-of-centre stance, *Picture Post* leant further to the left; Lorant's successor, Tom Hopkinson, got into trouble with his employers over his socialist leanings, and resigned. As well as using great photographers such as Bert Hardy, Thurston Hopkins and his wife Grace Robertson among many, *Picture Post* also had a talented writing staff, including MacDonald Hastings, J B Priestley, James Cameron, Fyfe Robertson and Robert Kee, all of whom went on to have successful careers elsewhere, particularly in television, after the magazine's demise in 1957. And as well as publishing picture stories where the text was limited to brief captioning, these writers would often be teamed with a photographer to great effect. It seems remarkable now, but when it closed *Picture Post* was still selling in excess of a half a million copies each week.

To see life; to see the world; to witness great events ... to see, and to be shown, is now the will and the new expectancy of half mankind.'

Henry Luce

Both *Life* and *Picture Post* had their day and were instrumental in raising the visual literacy of the public at large. By the time *Life* ceased weekly publication, in 1972, it was still printing several million copies, but it was much depleted and, with rising costs eroding profits, was no longer viable. Both titles, and picture magazines in general, had to bow inevitably to the cultural influence of the flickering cathode ray tube in the corner of the room.

Ernst Haas

Ernst Haas was the first photojournalist of note to adapt to the use of colour photography. Continuous experimentation and, later, his innovative portrayal of movement, would lead to the creation of Haas's most famous work.

Born 1921, Vienna, Austria
Importance The first photojournalist to adopt the creative use of colour photography
Died 1986, New York, United States

Haas would probably have been a doctor had it not been for the events of the Second World War. He began studying medicine in Vienna, in 1940, but his progress was blocked by the Nazi authorities, owing to his Jewish ancestry, and he switched his attention to photography. He entered the Graphic Arts Institute in Vienna but, like so many who went on to become great photographers, never completed his studies.

Haas' first photographic success was a series of pictures showing prisoners of war returning to Vienna, displayed in

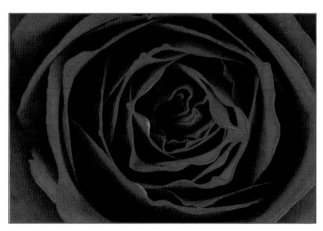

A close-up of the petals of a red rose, from Haas's book The Creation.

an exhibition at the Red Cross headquarters in 1947. The work was seen by the editor of *Heute* magazine, for which Haas subsequently began to work. When Robert Capa invited him to join Magnum Photos in 1949, he accepted.

Until this point, Haas had been photographing in black and white, but now he switched to colour. He shot the first colour essay published by *Life* magazine, 'Images of a Magic City', and supplied freelance picture stories to the major magazines of the day.

'I am not interested in shooting new things – I am interested to see things new.'

Some of his best-known images were published as 'Beauty in a Brutal Art' by *Life* in 1957. They documented the spectacle of the Spanish bullfight, shot in saturated colour, and with the experimental use of slow shutter speeds to describe the dramatic 'ballet' taking place. It was the first time this style of colour photography had been seen in print. The creative possibilities of mixing colours in this way, or 'painting with the camera', were explored further in 'The Magic of Colour in Motion', published in *Life* the following year.

This affinity for movement saw Haas shooting film stills, the ballet and sports, and he also tackled advertising campaigns for clients including Marlboro and Volkswagen. In 1964, John Huston had him direct the Creation section of his film *The Bible*. The theme of the Creation was something Haas would continue to work on, and it formed his first photo book, published in 1971; *The Creation* sold over one third of a million copies. His work was produced on colour slide film, which is ideally suited to audio-visual presentation, and this was a medium with which Haas experimented and was the way in which he regularly showed his work. This mode of display was also neatly attuned to his experiments with movement.

The innovative use of colour in his picture essays saw Ernst Haas add another dimension to the medium. And then, by extending this to describe motion in the still image, he developed a unique and powerful way of seeing.

August Sander

Since the mid-nineteenth century, photography has played an increasingly vital role in the recording and interpretation of history. One of the most ambitious documentary projects ever undertaken was conceived by German photographer, August Sander.

Born 1876, Herdorf, Germany
Importance Set himself the lifetime's task of recording the peoples of contemporary German society, so bequeathing the world an invaluable social document
Died 1964, Cologne, Germany

Sander took up photography as a teenager, while working at the local mine. He spent his military service (1897 to 1899) as a photographer's assistant and, after time travelling in Germany, moved to Linz in Austria, where, in 1901, he joined a photographic studio.
He became a partner in the business in 1902, in time returning to Germany, where he set up a new studio in Cologne in 1910.

In the early 1920s, Sander conceived the grand plan that was to become his life's work: 'Menschen im 20. Jahrhundert' ('Citizens of the Twentieth Century'). Here, he set out to photograph all of contemporary German Weimar society, presenting the nation by type in seven main groups – farmers and peasants, tradesmen, women, professions, intellectuals, artists and the unemployed, the homeless and displaced. The first part of this mammoth project was published as 'Face of our Time' in 1929. Sander photographed his subjects in part in the formal studio style, but had them pose in their workplaces with the tools of their trades close to hand, or in surroundings appropriate to their class.

By using this direct form of representation in 'collecting' people from society, Sander hoped to see an intrinsic natural order emerging through his work. In adopting attention to detail of environment, dress and expression, in an otherwise formal manner, his portraits

represent a sociology in pictures, a cultural and economic history.

Sanders was denounced by the Nazis in 1936. The diversity of physical characteristics revealed in his book did not conform to the Aryan ideal in representing the nation and was seized, banned and destroyed, along with the printing plates. During the Second World War, Cologne was heavily bombed and, in 1942, Sander moved to the countryside. In doing so, he preserved his delicate negatives, only to lose an estimated 40,000 of them in a disastrous fire a few years later.

Following the ban on his book, Sander turned to the landscape for subject matter and also photographed architecture and street life. But it is for his documentary portraiture that he is known. Edward Steichen included 45 of Sander's portraits in his monumental 1955 exhibition The Family of Man, at the Museum of Modern Art, New York.

Although August Sander lived to the age of 87, he died before completing his survey. *People of the Twentieth Century* was at last

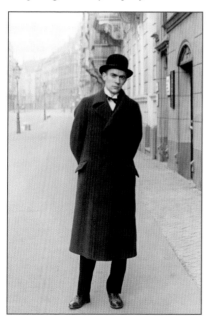

published in 1980, 16 years after his death and, in 2002, a new scholarly seven-volume edition, comprising 650 of Sander's 'types', finally completed the work he had begun 80 years previously. It is as fine an example as there is of the value of the photograph as document (see also page 48).

One of a series of Sander photographs of Weimar citizens.

Dorothea Lange

She began making paid portraits of moneyed clients, but Dorothea Lange's great contribution to photography – and the twentieth century – is seen in the eyes and furrowed faces of the desperate and downtrodden 1930s' migrant workers, whose plight she made public.

Born 1895, New Jersey, United States
Importance
Established the role of documentary photography as an instigator of social change
Died 1965, California, United States

Lange planned a career in teaching and began her studies in New York in 1914. However, she had a keen interest in photography and gave up teaching to study under Clarence H White, while assisting in a number of New York portrait studios. She moved to San Francisco and opened a successful portrait studio in 1919, which operated for more than 10 years.

The turning point in her career came with the great economic depression following the Wall Street Crash of 1929. Looking out from her apartment window in 1932, she was struck by a long file of people queuing for bread; she took up her camera and went out to photograph the scene.

She went on to photograph crowds of unemployed, hungry men and, in recording the harsh realities of everyday life for the poor, was one of the first photographers to document the human condition. Her work came to the attention of professor Paul Taylor at the University of California (later to become her second husband) who asked her to work with him on a report on seasonal farm labour. The pair's report on the plight of destitute migrant farm workers and their families led to the establishment of camps for shelter and provision of food.

Between 1935 and 1939 Lange worked as a photographer for the California Rural Rehabilitation Administration, later the Farm Security Administration (FSA). The organisation had been set up to gather evidence for the proposed New Deal legislation that was

'Damaged Child', Shacktown, Elm Grove, Oklahoma, 1936. The image is considered one of her most poignant portraits of children.

to support the disadvantaged in society by establishing minimum wages and maximum working hours. Lange's subjects were the sharecroppers and migrant farm workers whose poverty and bare hand-to-mouth existence her photographs helped publicise. In 1939, she and Taylor published *An American Exodus: A Record of Human Erosion*, documenting the mass migrations of the 1930s caused by changes to traditional agricultural practice.

Dorothea Lange believed that photographs could bring about change, and her commitment to making public the plight of the downtrodden did much to establish the documentary genre with which we are familiar today.

Henri Cartier-Bresson

Henri Cartier-Bresson was the greatest and most influential photographer of his generation. He was an artist at heart and claimed he saw photography as no more than: 'A way into painting, a sort of instant drawing'. Yet it was a medium on which he made an indelible mark.

Born 1908, Chanteloup, France
Importance Coined the phrase 'The Decisive Moment', inspiring successive generations of photojournalists
Died 2004, Mountjustin, France

It was while studying literature and painting at Cambridge that Henri Cartier-Bresson became interested in photography. He studied painting and drawing in the studio of André Lhote and, in 1931, left to travel to the Ivory Coast with his first camera, a Leica. The Leica I model had appeared the previous year and was the invention of Oskar Barnack. The camera used perforated 35mm cine film to produce a 24x36mm negative in what was known as the 'miniature' format; the Leica was very small, portable and unobtrusive. From the Ivory Coast, Cartier-Bresson and his Leica travelled around Europe for two years. His photographs were an immediate success and he continued his travels on assignment for various magazines.

The small camera allowed Cartier-Bresson to blend into the background and photograph without intrusion. He would wait patiently for the 'decisive moment' when the scene had arranged itself before him and described it thus: 'The simultaneous recognition, in a fraction of a second, of the significance of an event as well as a precise organisation of forms which gave that event its proper expression.'

He took for his subject ordinary aspects of everyday life, which through precisely considered composition and timing of exposure, he transformed into single-frame stories. His work reveals the inner truth of human existence and he travelled widely to record the situation of the world's people: 'I kept walking the streets, high-

strung and eager to snap scenes of convincing reality, but mainly I wanted to capture the quintessence of the phenomenon in a single image.' And it is the way in which he succeeded in doing so that marked him out as the greatest photographer of his generation, if not of all time.

In 1947, with fellow photojournalists Robert Capa, David 'Chim' Seymour, George Rodger and William Vandivert, Cartier-Bresson founded the Magnum Photos agency. In 1952, he published his first book, *Images à la Sauvette* (literally, 'pictures taken on the sly') which, in the English edition was retitled *The Decisive Moment*. It is a book and philosophy that have inspired photographers ever since.

Cartier-Bresson began to turn away from photography in the mid-1960s, to return to his passion for painting, although Magnum continued to distribute his pictures.

One of the greatest photographers of the twentieth century, Henri Cartier-Bresson was an influence and inspiration to generations. As well as an extensive archive of remarkable photojournalism, his legacy includes that pillar of photographic humanism, Magnum Photos.

Henri-Cartier Bresson, widely regarded as one of the great photographers of the 20th century, pictured in Paris in September 1989.

Photographing the Everyday
Lee Friedlander

Lee Friedlander was one of a number of photographers championed by the influential John Szarkowski, director of the photography department at the New York Museum of Modern Art from 1962 until 1991. Friedlander photographed the social landscape of the city in a way that captured the look of modern life.

Born 1934, Washington, United States
Importance Documents commonplace American life in an uncommon and arresting way

Friedlander began taking photographs at the age of 14 and studied photography at the Art Center College of Design in Pasadena, California – although he didn't stay there long because: 'The assignments were too boring'. One of his tutors suggested that he should pursue his

A slice of American life, Newark, New Jersey, 1962.

career in New York, and he moved there in 1956, where he started by photographing jazz musicians. He was an admirer of the work of Eugène Atget and near contemporaries Robert Frank and Walker Evans, and saw himself carrying forward the tradition they had begun.

Like many street photographers, Friedlander worked in black and white with unobtrusive Leica cameras and was a key figure among the generation of 1960s photographers who sought to document everyday life without artifice. His first solo exhibition was held in 1963, at George Eastman House, and in 1967 the Museum of Modern Art staged a landmark show, 'New Documents', where his work appeared alongside other Szarkowski favourites, Garry Winogrand and Diane Arbus.

Friedlander's work organises and conveys the visual chaos of the urban environment, imposing an order and meaning on the messiness of everyday life. He places himself in his world, often literally, but you may have to look hard for the shop-window reflection or maybe his shadow. Usually this intrusion of the photographer into the photograph would been seen as a mistake but, in Friedlander's case, he is showing that the photographer is also a performer whose hand is impossible to hide. His subject matter is usually commonplace, but hugely varied, and photographed in a consistent style – cars and people on the street, the jazz musicians, flowers, trees, telegraph poles, the city's structures and memorials, rear-view mirrors, workers, motel rooms, landscapes, television screens, direct and indirect self portraits, nudes – in the latter case, some of his most famous images are of Madonna when she was plain Ms Ciccone in the late 1970s, published in *Playboy* in 1985.

Unlike his contemporaries Winogrand and Arbus, whose subjects are often bizarre and, therefore, demanding of the viewer's attention, Friedlander begins with the commonplace then presents it in uncommon ways. Much of the work suggests the jazz tradition: a freedom of improvisation combined with complex formal structures. Although his work is in essence documentary, it has been extremely influential – along with that of some of his 1960s contemporaries – in the development of photography as an art form.

THE PHOTOGRAPH AS DOCUMENT

Since its inception, photography has been used to record people, places and events. For many, this is the essential value of a photograph – the ability to document. One of the most remarkable projects of this kind was undertaken by the Farm Security Administration (FSA) in 1930s' America.

During the Great Depression thousands of poor tenant farmers, or sharecroppers, became displaced, many forced into towns and cities to find work. That these were desperate times did not go unnoticed by politicians. In 1935, President Franklin D Roosevelt set up the Resettlement Authority (RA) with a view to providing aid to the struggling rural families, and put Undersecretary of Agriculture, Rexford Tugwell, in charge. The resettlement money that was part of the plan required public support and Tugwell appointed his former student, Roy Stryker, to head the RA's historical section.

To document the situation, Stryker hired photographers including Walker Evans, Dorothea Lange, Carl Mydans and Arthur Rothstein; when funds allowed, others, including Russell Lee, Jack Delano and Gordon Parks, joined the team. The RA became the FSA, as it is now more commonly known, in 1937, when it was absorbed into the Department of Agriculture.

Stryker set about formalising the work of the FSA. He set an official documentary style, held briefings and developed shooting scripts for assignments. The aim

> *'A documentary photograph is not a factual photograph per se. It is a photograph which carries the full meaning of the episode.'*
>
> Dorothea Lange

was to show the public the reality of these people's daily struggle and so win popular support for Roosevelt's relief plan and, to this end, Stryker established publishing contacts to ensure the FSA's words and pictures reached their audience. In truth, while the photographs are today considered documentary, their intention at the time was close to propaganda. They were not producing works of fiction, but great care was taken to promote a positive impression of disadvantaged but decent folk, deserving of support. At the time 'documentary' photographs were believed as statements of fact – now we understand them to carry a message.

The photographers developed their film in the field, captioned the pictures and sent them back to headquarters in Washington, where they were printed ready for publication. Of the many notable photographers associated with the FSA, probably the one whose work was to have the greatest influence on future practitioners was Walker Evans. He worked with a 10x8in camera and would disappear into the field for weeks at a time, returning with clinically objective images that convinced with their apparent lack of artifice.

In the summer of 1936, Evans teamed up with friend and writer, James Agee. On assignment for *Fortune* magazine they documented the lives of sharecropping families in Hale County. The article was rejected but was to appear in much expanded form as *Let Us Now Praise Famous Men*, published in 1941. Now acknowledged as a seminal work, this book did not meet with initial success, selling fewer than 600 copies in its first year. That this was a collaboration between two independent observers, one a photographer the other a writer, is emphasised by the way the two work to complement, rather than illustrate, each other. For example, the book opens with a portfolio of Evan's photographs, rather than the text that might have been expected. *Let Us Now Praise Famous Men* may have got off to a slow start, but the conviction of Evans and Agee is vindicated by the fact it remains in print to this day.

Set up to garner popular support for a political ends, the FSA's legacy is a vast archive and some of the finest photographers known.

William Eggleston

Spurred on by his discovery of 'the ultimate print' William Eggleston was to introduce colour to modern documentary photographic practice. Despite attending three universities over six years, he never graduated, but he developed an interest in photography after a college friend gave him a camera, and his introduction to abstract expressionism in art class had a marked effect on his approach to the medium.

Born 1939, Memphis, United States
Importance Was at the forefront of the New Colour Photography movement in the United States and elevated the snapshot to an art form

Eggleston's first photographs were made in black and white, inspired by Robert Frank, the documentary work of Walker Evans and the philosophy expressed by Henri Cartier-Bresson in his book *The Decisive Moment*. He began to experiment with colour photography in the mid-1960s, and it was while scanning the price list at his local chemist's film-processing desk

'Greenwood, Mississippi' (1973) by William Eggleston.

that he came across the dye-transfer process. Amazed at the strength and saturation of colour, he adopted it as his process of choice.

Eggleston was a central player in the New American Colour Photography movement of the 1970s (many consider him its 'inventor'), along with figures such as Stephen Shore, Joel Meyerowitz, Joel Sternfeld and Richard Misrach. Colour began to replace formalist, pictorial, black-and-white, handcrafted prints, and proved a much better medium for documenting the tacky age of bad taste and consumption of the times. Colour introduced a subjectivity to the work that helped deliver the message.

In 1969, Eggleston had visited John Szarkowski at the New York Museum of Modern Art (MoMA), one of the most – if not the most – influential figures in photography of the late-twentieth century. Szarkowski was sufficiently impressed to persuade MoMA to buy one of his prints. In 1976, a landmark in photography occurred when Szarkowski exhibited Eggleston's work as the first-ever solo show of colour photographs at MoMA. Following this stamp of approval from the art world, the colour photograph has never looked back. That's not to say that, Eggleston's superficially mundane 'snapshots' met with universal acclaim, but the ball was set firmly in motion; debate – the oxygen of publicity – was instigated and argument ensued.

> **DYE-TRANSFER**
> A colour-print process introduced by Kodak in the 1940s, capable of an extremely high range of colour tones and exceptional image permanence.

Eggleston is not a documentary photographer in the journalistic vein of Dorothea Lange or Sebastião Salgado, but his images all portray life – his life – and what surrounds it. Although superficially quotidian, his subjects' beauty and complexity are revealed by his artist's eye, taking on a new significance. He has the ability to find beauty in the vernacular.

Despite resistance from some quarters of the art world to his 1976 MoMA show, the pioneer work of William Eggleston is now universally accepted as a landmark in modern photography and the point at which art's attitude to the medium began to change. It taught America, and subsequently the world, another way of seeing.

Martin Parr

Martin Parr rose to prominence during the blossoming of British 'social documentary' photography in the 1980s. He had begun photographing in black and white, but it was a shift to colour, using fill-in flash, that produced his unique style of strident, garish tones.

Born 1952, Epsom, England.
Importance Developed a brash and innovative style of vivid colour photography that became instantly recognisable as the New British Colour Documentary mode

Parr's subject matter is invariably on a social theme, in particular the idiosyncrasies of the British and its class system. He is a prolific publisher of books and the ironically titled *Last Resort* – photographs of the working-class seaside town of New Brighton, published in 1986 – was his breakthrough. Photographed in what by then was his trademark style, Parr's subjects are captured blithely unaware, enjoying their chips and ice creams among the detritus of discarded paper cups and cigarette ends, sunburnt lobster-red against a background of tatty beach huts, reading tabloid newspapers in knotted handkerchiefs: the archetypal British on holiday.

The increased interest in social documentary photography in 1980s Britain was, in large part, a response to unpopular government policies during Margaret Thatcher's premiership. More picture stories on social themes were being made and published, providing a platform for Parr and his contemporaries. Matters of taste have been an abiding theme for him: he contributed the photographic illustration for Nick Barker's film *Signs of the Times*, in which people's tastes in interior decoration are dissected mercilessly. It may have been Barker's film, but the subject and the execution was quintessential Parr.

Although his style was superficially at odds with the reputation of prestigious humanist photo agency, Magnum Photos, Parr joined the cooperative in 1994. The agency was based on a serious commitment

to reportage and photojournalism, typically in black and white, and Parr's association with the group did not meet with universal approval among some of the longer established members.

A particularly notable achievement was the two-volume *The Photobook: A History* (2004 and 2006), which Parr co-authored with critic, Gerry Badger, and in which more than 1,000 of photographs from the nineteenth century to the present day are celebrated.

The combination of Martin Parr's unique style and wry humour made his work stand out in a genre that was burgeoning in the 1980s. Futhermore, because his trademark style could be applied successfully to commercial photography – advertising and fashion – and its quirkiness provided book publishers with ready-made best-sellers – his influence on the medium has been greater than any other of his generation.

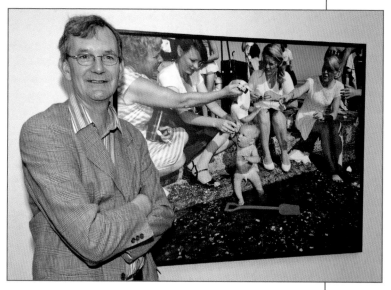

Martin Parr poses next to one of his photos from the series The Last Resort. *This wry and ironic treatment of the subject matter is typical of Parr's work.*

Sebastião Salgado

Having dedicated his life to documenting the human condition, Sebastião Salgado's photography has been considered controversial in that he creates powerful images whose beauty belies the nature of their subject. His style introduces subjectivity into the journalism, deliberately making the message more disturbing.

Born 1944, Aimorés, Minas Gerais, Brazil
Importance The most significant photographer of the human condition in the late-twentieth century

Having moved from his native Brazil to Paris, Salgado completed an economics doctorate in Paris and went to work with the International Coffee Organization in London. He travelled regularly to Africa on assignment with the World Bank and, during one of these trips, took up photography, deciding to pursue it full-time in 1973. Salgado moved back to Paris, working on news assignments and covering events such as the war in Angola and the Portuguese revolution. During an extended stay in an Ethiopian refugee camp Salgado lost faith with news reporting as he witnessed, first-hand, the way the numerous camera crews came and went in a matter of hours. He decided to stop taking on magazine assignments and committed himself, instead, to self-initiated in-depth documentary projects.

Initially, he worked for the Paris-based photo agency Sygma, then with Gamma, subsequently joining Magnum Photos in 1979. His work took him all over Africa, Latin America and Europe. He left Magnum in 1994 to form his own agency, Amazonas Images, which represents his work and is run as a charity, raising money to protect the rainforest.

The body of work that brought Salgado to the attention of the world, and still perhaps his most famous, was a black-and-white essay, made in the mid-1980s, documenting the working conditions of

Salgado poses at an exhibition of his work. His outstanding humanist photo essays are unsurpassed in scale and significance.

miners at the Serra Pelada goldmine in Brazil. His pictures show many hundreds of mud-caked workers descending into the womb of the mine down rickety wooden ladders of improbable height, and struggling up again weighed down with sacks of ore. The monumental size of the earthworks and the desperate endeavour of what, at a distance, resembles an ants' nest, are breathtaking.

He has published many books, the first, *Other Americas*, was a lengthy photo essay on the lives of Latin-American Indians and peasants. This was followed by *Sahel: End of the Road*, depicting the consequences of famine in Africa, which was published in support of Doctors Without Borders, alongside whom he had worked.

Salgado's work stands out for its epic scale and the length of time he devotes to each project. For example, *Workers*, published in 1993, was the culmination of research into manual labour across 23 countries and six years. For his follow-up project, 'Migrations', he spent seven years photographing in 39 countries, documenting population migration: mass movements of people caused by politics and war, famine or economic pressures, or a combination of any or all of them.

Julia Margaret Cameron

Among the eminent photographers of history, Julia Margaret Cameron is unusual in that she came late to the medium and, measured by the standard practices of the day, appeared not to be terribly good. However, she had the eye of a Pre-Raphaelite artist and her non-conformist style came to be appreciated, which, along with her famous portrait subjects, has ensured the endurance of her work.

Born 1815, Calcutta, India
Importance Broke all the rules of portrait photography in pursuit of her art
Died 1879, Kalutara, Sri Lanka

Cameron was born into the privileged upper echelons of British colonial society in India. At 23 she married a diplomat. The couple had five children and, in 1848, the family returned to England. Their house became a meeting place for artists, writers and scientists of the day. When Cameron was 49, her daughter gave her a camera and she proceeded to teach herself the wet-collodion process; a coalhouse was converted into a darkroom, and a studio improvised out of a glass-roofed chicken run. She began by getting domestic servants and family members to pose in staged scenes and portraits.

Ignoring much standard photographic practice, Cameron tried to capture a more spontaneous image of the essence of her sitter. She would photograph portraits close up with a long-focus lens, introducing unfamiliar perspective, and would not use supports to steady the subject during the several-minute-long exposures, thus a variable degree of blurring was inevitable. Cameron employed highly directional lighting, another unconventional approach, and ignored the 'rules' of focus, preferring a selective focus style to introduce fresh points of emphasis.

Where commercial portrait photographers strove for clarity and detail, Cameron worked by suggestion, less to capture a facsimile of

the sitter than an impression or suggestion. She composed her portraits as tight head-and-shoulders shots, in contrast to the full-length style of the commercial studio with its fancy painted backdrops, grand costumes and props referring to classical architecture and the like.

'When focusing and coming to something which, to my eye, was very beautiful, I stopped there instead of screwing on the lens to the more definite focus.'

Because her style was so at odds with the norm, Cameron's talent was undervalued at the time. It was not until a new generation of photographers came along that her work became elevated to its proper place in the history of the medium, in being the first to hold its own with portrait painting.

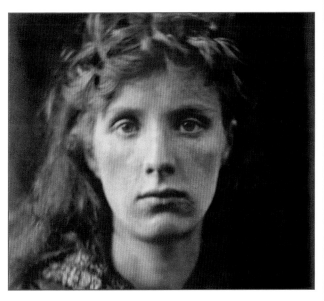

In her portraits, Cameron sought to produce romantic and allegorical imagery in the manner of the Pre-Raphaelites.

Walker Evans

Walker Evans worked in an objective style in pursuing 'documentary' imagery, a detached, objective photographic style, in which he was influenced by he work of Eugène Atget and Paul Strand. Making portraits in this way made him one of photography's most influential figures.

Born 1903, Missouri, United States
Importance
Introduced an objective documentary approach to portraiture
Died 1975, Connecticut, United States

After graduating from Phillips Academy, Massachusetts, Evans studied literature for a year and then dropped out. He moved to Paris, hoping to become a writer, but returned to New York after a year. Here, he moved in art and literary circles, giving up on the writing around 1930 and turning to photography.

In 1938, he was the first photographer to be honoured with a solo exhibition at the New York Museum of Modern Art (MoMA), with 'Walker Evans: American Photographs'. From 1935, he worked with the Farm Security Administration (FSA), documenting the effects of the Great Depression on America's rural population. His pictures made the families icons of Depression-era misery to the extent that descendants were later to suggest the pictures were misleadingly unflattering.

In 1938 Evans began a unique project, surreptitiously making portraits of travellers on the New York subway. He photographed passengers with a hidden camera pointing through his coat buttons. The conventions of public transport are the same the world over: passengers sit internalised, steadfastly ignoring one another, wholly wrapped up in themselves. Evans' approach derived from his search for true objectivity, what he described as the 'ultimate purity' of the method of recording. In this respect he was very unusual among portrait photographers: far from seeking to engage with his subjects, he tried to avoid them at all costs. The photographer was to be no part of the photograph.

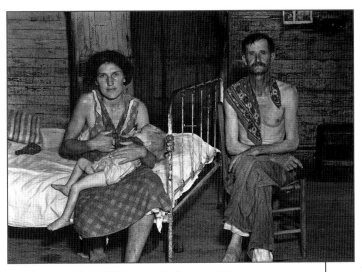

Evans's portraits for the FSA were simple, frontal and direct.

By 1941, Evans had over 600 of these subway portraits and began to edit them into a book. It was not until 1962, however, that a selection appeared in print. In 1966, the MoMA staged an exhibition of the work and the book was published under the title *Many Are Called*, with an introduction by his friend and collaborator, the writer James Agee. In it, Agee writes about the 'guards' we put around ourselves in posture and facial expression, and how these are let slip during the isolation of subway travel:

> The simplest or the strongest of these beings has been so designed upon by his experience that he has a wound and nakedness to conceal, and guards and disguises by which he conceals it. … Only in sleep … or in certain waking moments of suspension, of quiet, of solitude, are these guards down.

Walker Evans extended this approach to street photography. At the time, his style of portraiture was unique, and this marks him out as one of the most influential photographers of the twentieth century.

Yousuf Karsh

Portrait photographer, Yousuf Karsh, employed a style of posing and lighting that was so instantly recognisable that he became synonymous with his technique. He combined a unique graphic style with an unerring ability to get behind the mask of his eminent subjects and, in doing so, made them look every bit as important as they were.

Born 1908, Mardin, Armenia
Importance Used dramatic lighting to photograph significant figures of the twentieth century
Died 2002, Ottawa, Canada

Karsh was born to Christian parents and grew up during the Armenian genocide. When he was 14 the family fled to Syria and his parents sent him to live with his uncle George Nakash, a photographer, in Canada. Karsh served his apprenticeship with his uncle who, in 1928, arranged for him to study with the portrait photographer John Caro, where he learned the techniques of art photography. In 1932 he opened his own studio.

At the theatre in Ottawa, Karsh was introduced to the use of incandescent lighting, which he adopted for his portraiture, and which was to contribute to his unique style. In 1941, during the Second World War, British Prime Minister, Winston Churchill, delivered a speech to the Canadian House of Commons in Ottawa, after which Karsh took his famous portrait of him . According to the photographer, Churchill marched into the room scowling, 'regarding my camera as he might regard the German enemy. Instinctively, I removed his cigar. At this the Churchillian scowl deepened, the head was thrust forward belligerently, and the hand placed on the hip in an attitude of anger.' An image of defiance, the shot was used on the cover of *Life* magazine and established Karsh as a portraitist of international significance.

During his long career, Yousuf Karsh photographed many of the great and the good – writers, actors, artists, presidents, architects,

Karsh's portrait of Queen Elizabeth II was used on the 45p stamp in the UK.

popes and princesses. He photographed for much of his career with a 10x8in plate camera. In combination with the strong lighting, this produced portraits of intimate detail, ideally suited to reproduction on the printed page. He published 15 books of his photographs, in one of which, *Karsh Portfolio*, 1967, he wrote:

> Within every man and woman a secret is hidden, and as a photographer it is my task to reveal it if I can. The revelation, if it comes at all, will come in a small fraction of a second with an unconscious gesture, a gleam of the eye, a brief lifting of the mask that all humans wear to conceal their innermost selves from the world. In that fleeting interval of opportunity the photographer must act or lose his prize.

Diane Arbus

Diane Arbus enjoyed success as a fashion photographer, but switched to photojournalism and a style of portraiture that was to bring her fame and controversy in equal measure. Although her style was considered ruthless by many, it was to have a major influence on future documentary portraiture.

Born 1923, New York, United States
Importance Arbus introduced a confrontational and influential style of portraiture to documentary photography
Died 1971, New York, United States

Diane Nemerov was born to a wealthy Jewish family, her father the owner of a Fifth Avenue department store. She married childhood sweetheart Allan Arbus who was training as a photographer for the US Army. They began working as a team and her father asked them to take advertising photographs for his store. Arbus was still very young when the couple set up a fashion studio taking pictures for magazines such as *Harper's Bazaar*.

Arbus began to make her own photographs and studied under Lisette Model, in New York, from 1955. In 1959 she and her husband separated and, encouraged by Model to concentrate on her personal work, Arbus abandoned fashion and undertook further study with Alexey Brodovitch and Richard Avedon. Under Model she had developed a documentary style of portraiture, photographing a range of subjects on the margins of society – the excessively big and small, transvestites, the mentally disabled, addicts, eccentrics and twins. Arbus photographed in a confrontational style, her subjects looking directly at the camera which, in combination with her choice of subject and the way in which they appeared willing to parade their flaws, made her pictures controversial. They remain so today.

From 1960 Arbus worked as a photojournalist for many of the major magazines including *The New York Times* and *Sunday Times* magazines, *Esquire* and *Harper's Bazaar*. Her work was supported by

Diane Arbus. So controversial was her work that publishers rejected an opportunity to publish a restrospective exhibition catalogue for MoMA.

the award of Guggenheim Fellowships in 1963 and 1966, and its importance recognised by inclusion in the 'New Documents' exhibition in 1967 at New York's Museum of Modern Art (MoMA), alongside that of Garry Winogrand and Lee Friedlander. The controversy surrounding her work stemmed from choosing apparently vulnerable subjects to produce pictures that appeared to share the questionable appeal of the one-time circus 'freak' shows. Conversely, she sought to dignify their personal tragedies.

By 1970, Arbus had established an international reputation as a pioneer of the 'new' documentary. She experimented using daylight flash to highlight and isolate her subjects, a technique that would be successfully exploited by others, among them Martin Parr. Arbus committed suicide in 1971, which brought even more attention to both her and her work.

The documentary portraiture of Diane Arbus may have had its critics, yet it was widely published and attracted large audiences. Today, her influence is universally acknowledged and is there to be seen in the work of subsequent generations.

Robert Mapplethorpe

Through his stylised portraits of celebrity friends and explicit homoerotic studies, Robert Mapplethorpe sprang to prominence in the 1970s. His work was very much of its time: edgy imagery of gay sexual freedom, fetishism and the notion of photography as an art form.

Born 1946, New York, United States
Importance His work stimulated debate at a time when sexual freedom was being reined in by the fear of AIDS
Died 1989, Boston, United States

Mapplethorpe studied painting at the Pratt Institute in Brooklyn. He made his first photographs in 1972, using a black-and-white Polaroid camera. His early subjects included self-portraits and nudes, portraits of singer Patti Smith, with whom he lived in Manhattan, friends and artists, and still lifes, particularly flowers. By the mid-1970s, he was photographing seriously, still in black and white. He worked mainly in the studio making precise graphically composed arrangements for portraits and still lifes, carefully lit and beautifully printed.

Mapplethorpe's first studio was in Bond Street, Manhattan. He had met curator and collector, Sam Wagstaff, who became his lover, in 1972. In the 1980s, Wagstaff gave him the money to buy a loft on West 23rd Street, which doubled as his studio and living quarters, while he retained the Bond Street studio as his darkroom. On meeting pornographic-film actor, Ben Green, Mapplethorpe became inspired to push the boundaries of his photography. He began to produce highly eroticised imagery, including a nude portfolio of the body-builder Lisa Lyon and, in particular, homoerotic and sadomasochistic nudes and portraits.

Although the New York avant-garde scene lapped up his work, Mapplethorpe was not universally applauded. He inevitably became known for his sexually-charged nudes and portraits. His work regularly appeared in publicly funded galleries, which conservative

and religious groups latched onto as a reason to attack it. Indeed, it was not just those with a right-of-centre stance who criticised his work: Mapplethorpe made many erotic images featuring black males and, in the early days of political correctness these led to accusations of exploitation. But the work attracted more controversy than successful censorship: a 1990 posthumous exhibition 'The Perfect Moment', which included seven sadomasochistic portraits, resulted in the Contemporary Arts Center of Cincinnati and its director being prosecuted for 'pandering obscenity' (although the action failed).

Mapplethorpe died from an AIDS-related illness in 1989. Shortly after this, the Concoran Gallery of Art in Washington DC had been due to host an exhibition of his work, but refused to do so on realising that it would include a new series of overtly sexual images. Mapplethorpe was vindicated, however, when the small, non-profit Washington Project for the Arts exhibited the work to great critical acclaim.

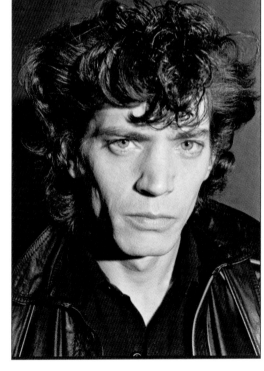

With the highest standards of art in the studio and the darkroom, Mapplethorpe elevated under-the-counter imagery to the gallery wall.

SEX AND THE CAMERA

Although one is considerably older than the other, sex and the camera have had a long relationship; and like most long relationships it has not always been plain sailing. The line between erotica and pornography moves with the times and is further complicated by the degree to which the artist attempts to push the boundaries.

Photography was quickly seen as an ideal medium for erotica. It portrayed the real and, for commercial purposes, 'dirty postcards' were cheap and easy to reproduce. Voyeurism was encouraged without the risk of being caught. The nude, with its 'artistic' credentials, became a popular subject among amateurs. Camera clubs would – and still do – hold 'glamour' sessions, with paid models facing a barrage of shaking members' lenses. In the days before ubiquitous sexual imagery, you could rent a city studio, camera and model by the hour, although it is rumoured that the camera rarely had any film in it.

The popular photo magazines of the mid-1960s to mid-1980s became obsessed with sex: everyone seemed to be at it in the battle for copy sales. Every cover featured a semi-nude 'dolly bird', and the link between photographers and sex was so thinly veiled that the classified section at the back carried advertisements from prostitutes posing as 'glamour' models and brothels claiming to be studios.

The Sun newspaper invented the 'Page 3 Girl', an anachronism that still persists. An honest Polaroid executive would admit to knowing to what purpose many of his company's products were put, a market in which they had a profitable monopoly. Then came video and the digital camera.

The world of the professional and art photographer was not immune. Helmut Newton, Jeanloup Sieff, Guy Bourdin and others

introduced nudity and fetishism into their fashion photography from the 1960s. Robert Mapplethorpe dragged homosexual sex acts from behind closed doors to the gallery walls, meanwhile developing his personal aesthetic of the male nude. Nobuyoshi Araki continues to tie up and photograph hapless naked women to this day. All of them enjoy huge commercial success.

> 'When I have sex with someone I forget who I am. For a minute I even forget I'm human. It's the same thing when I'm behind a camera. I forget I exist.'
>
> Robert Mapplethorpe

Issues surrounding the portrayal of 'under-age' models have come to the fore in recent years, but it is not a new topic of controversy. It is said, although cannot be proven, that Charles Lutwidge Dodgson (Lewis Carroll) was 'warned off' for his photographs of sexualised young girls; whether this actually happened we cannot say, but he certainly stopped producing them. More recently photographers such as Sally Mann and Jock Sturges, among others, have attracted controversy with nude photographs of young girls or boys: in the former case involving her own daughters, and in the latter drawing the attention of the FBI, who confiscated his work and equipment. Although after a year's investigation Sturges' case was thrown out by a grand jury, he continues to be attacked by conservative politicians and religious groups, and life is generally made difficult for him. It is a topic that has inspired a public frenzy, to the extent that young parents dare not take photos of their baby in the bath lest the photo-lab report them to the police and the care officers come knocking at the door.

All of the above attests not only to our fascination, obsession even, with a subject that is as old as the hills, but to the enormous power of photography as a medium of representation and expression.

Annie Leibovitz

Annie Leibovitz has become the portrait photographer of choice among the upper echelons of screen stars and musicians. Her witty and empathetic style of portraiture has arguably done as much to enhance the reputation of her subjects as have their own performances on stage and screen.

Born 1949, Connecticut, United States
Importance Portrays often-photographed celebrities in a fresh and revealing way

Anna-Lou Leibovitz was born to a modern-dance instructor and an officer in the US Air Force. During the Vietnam War, her father was assigned to the Philippines and it was here that she took her first photographs. Back in the United States, she studied at San Francisco Art Institute and continued photographing while undertaking various jobs, including a spell working on a kibbutz in Israel in 1969. Leibovitz returned to the United States in 1970 and worked for *Rolling Stone* magazine; she became its chief photographer from 1973 until 1983. Her intimate star portraits helped define the magazine's look and feel.

She gained international fame in 1980, when she photographed a nude John Lennon with Yoko Ono for the cover of *Rolling Stone.* The naked Lennon clings vulnerably to his partner in a pose typical of the collaborative way in which she works with her subjects. That her subjects are invariably celebrities, yet will perform for her camera in all manner of surprising ways, is what has marked out her work from that of her contemporaries.

Leibovitz creates images that flatter her subjects, but not simply in a conventional way: She shows that the stars have a sense of humour, are lacking pomposity, are unafraid to make fun of themselves; they may be celebrities but they're human, and probably quite nice people, too. Her pictures allow her subjects to show they

are more than two-dimensional screen ciphers. Her A-list subjects have ensured that the pictures are widely published beyond their original homes, many becoming modern icons. A heavily pregnant, naked Demi Moore graced the cover of *Vanity Fair*; Whoopi Goldberg threw off her clothes and jumped into a bath of milk; Dan Ackroyd and John Belushi posed as the Blues Brothers, slathered in blue face make-up.

As has happened with many successful photographers, an element of controversy has followed Liebovitz. In addition to the Lennon and Moore images, a portrait of the actress Miley Cyrus attracted media attention because, although shot from behind, Cyrus appeared to be topless and was only 15 at the time. The previous year, through no fault of her own, Leibovitz had been involved in another fuss when a badly edited trailer for a BBC television programme covering a portrait session with HRH Elizabeth II suggested that the queen had stormed out of the studio.

Leibovitz met the writer and critic, Susan Sontag, in 1989, when taking her portrait for a book jacket; they became lovers, although they lived separately until Sontag's death in 2004.

Sarah Jessica Parker by Annie Leibovitz.

Horst P Horst

Horst P Horst's career in fashion and portraiture spanned a remarkable six decades, during which time he became known for his stylish portrayal of desirable elegance. The first exhibition of his work was held in Paris, in 1932. The show was reviewed in The New Yorker to such acclaim that Horst became famous overnight.

Born 1906, Weissenfels, Germany
Importance Creator of timeless icons of elegant glamour
Died 1999, Florida, United States

Horst studied architecture in Hamburg then moved to Paris in 1930, where he was apprenticed to the architect, Le Corbusier. In Paris, he moved in artistic circles and met *Vogue* photographer George Hoyningen-Huene; Horst became his model and lover. Travelling to England, they met Cecil Beaton, then working on the British edition of *Vogue*, and encouraged by Hoyningen-Huene, Horst took up photography. French *Vogue* published his first photograph in late 1931 and he joined their staff the following year, taking over from Hoyningen-Huene as head of the Paris studios in 1934.

Horst's work is known for its careful use of lighting, in particular back- and top-lights. Props were commonly worked into his carefully planned compositions, arranged in advance so that when the model arrived on set, primed with short, precise instructions, the pictures could be made without delay. His best-known photograph is a 1939 advertising shot for French *Vogue*. 'Mainbocher Corset' sums up Horst's style well and makes reference to his interest in surrealism. The classical notion of beauty, prevalent in the 1930s and central to Horst's oeuvre, is captured by the pose and the directional lighting, itself suggestive of an old master painting. There is an erotic charge to the image, implications of bondage and mystery, evoked by the model's hidden face, her back to the camera revealing the laced workings of the undergarment.

In the late 1930s, Horst moved to New York and worked on American *Vogue*. He joined the US Army in 1943 and was granted American citizenship, working as an army photographer until the end of the war. As well as his fashion work, Horst was an accomplished portrait photographer. Prior to army service, he had photographed well-known actors and musicians – such as Bette Davis and Cole Porter – and after the army, his subjects extended to US Presidents and, in particular, their wives, America's First Ladies. Post-war he continued with *Vogue* in New York until its studio closed in 1951.

There is an obvious degree of commonality in fashion and portraiture and it is far from unusual for photographers to work in both fields; Horst, less conventionally, also followed his early interest in producing studies of interior design and architecture, working for *House & Garden* magazine for several years. A collection of these images, *Horst: Interiors*, was published in 1993. He also photographed nudes and still lifes.

A Horst P Horst photograph entitled 'Divers' for AJ Izod Swimwear, taken in 1930.

Cecil Beaton

Cecil Walter Hardy Beaton created fashion photography in a theatre of dreams. His work portrayed how the 'other half' lived and to what heights one might aspire, to be truly fashionable.

Born 1904, London, England
Importance Employed his affinity for the theatre to promote high fashion
Died 1980, Wiltshire, England

The fact that Beaton learned photography from his nanny tells us much about his roots. He was born into a wealthy London family. His father, Ernest, was a successful timber merchant and, like his wife Etty, a keen amateur actor. Beaton was an artistic, rather than academic, child and attended the famous Harrow public school. He read history, art and architecture at Cambridge University but failed to graduate. He then joined the family business and remained on the payroll for a mere eight days. At university he continued with his photography and sold his first photos – portraits of theatre director George Rylands – to *Vogue* magazine.

Beaton developed parallel careers alongside photography, designing sets, costumes and lighting for stage and film; he won Oscars for costume design on the films *Gigi* (1958) and *My Fair Lady* (1964). His talent was a progression from his photographic style; he was known more for his theatricality than his technical expertise.

Building on photographic experiments at university, Beaton learned his craft in the studio of theatre and portrait photographer Paul Tanqeray, during the mid-1920s. In 1927 *Vogue* began to use him regularly, an association that lasted for over five years.

Beaton's social position gave him access to many prominent figures and commissions. He met, and became friends with, the Sitwell literary family in 1929, photographing them, and Edith Sitwell in particular, for over 30 years. He became the official

photographer of the British Royal Family from 1939, making many portraits for publication. His fashion photography was very much about the business of being fashionable. He often used actresses as models, women who could act the part as well as look it. Sets and accessories combined with couture and pose to paint a picture of luxury and wealth. The sumptuousness of his

Gloria Vanderbilt in a polka dotted dress, photographed by Cecil Beaton.

imagery was the antithesis of the principle that 'less is more' and frankly at odds with the modern trends, but it was precisely attuned to the tastes of those for whom he was photographing – the fashion elite of *Vogue*, *Vanity Fair* and *Harper's Bazaar*.

Beaton was as well known for his portraiture as for his fashion photography. With access to the British aristocrats and intellectuals, and famous actors and actresses, he produced work that was widely published. His subjects included Marlene Dietrich, Audrey Hepburn, Coco Chanel, Jean-Paul Sartre, Marlon Brando and Elizabeth Taylor.

Beaton's career was to stretch from the 1930s to the 1970s, during which time he would meet and influence others, including David Bailey, who took up where he had left off. Following a stroke in 1974, he negotiated the sale of his archive, which, over a period of years until his death, provided him with an income.

Irving Penn

Irving Penn's early studies in graphic design produced a photographer with immense powers of composition, shape, line and form, who stripped back the elements he photographed with minimalist simplicity and set the agenda in fashion and portraiture for years.

Born 1917, New Jersey, United States
Importance A long and varied career at the very top of his profession

Irving Penn and Richard Avedon have a great deal in common. Both studied under the influential art director, Alexey Brodovitch, made fashion photographs for the likes of *Vogue* and *Harper's Bazaar*, had individual styles that were much imitated – including posing subjects against plain backgrounds – and were highly talented portraitists. The most notable difference between the two, aside of Penn's slight seniority, is that he did not enter the world of the great fashion magazines as a photographer, but as a designer.

Penn studied art and design under Brodovitch in New York, graduating in 1938, the year after several of his drawings had been published in *Harper's Bazaar*. He began working as a freelance designer and, from 1940 to 1941 was an art and advertising director at Saks Fifth Avenue. He then became assistant to the art director of *Vogue*, Alexander Libermann, at first producing cover illustrations, then cover photographs and editorial shots for the inside pages, from 1943. Libermann encouraged Penn in his photography and commissioned him to make a portrait series for the magazine; his first fashion photographs appeared in *Vogue* in 1944.

Penn developed a studio-based style that involved shooting against plain white or neutral grey backgrounds. He built an angular 'corner' in his studio from whitewashed flats into which he would squeeze his often-famous subjects; the unconventional space tempted them out of the usual poses. Despite favouring the controlled formal environment

of the studio, Penn worked with natural daylight. He maintained the same degree of control on location, employing a portable studio comprising a seamless background roll, and, whatever his subjects, he always photographed with the same careful, compositional structure.

During his long career, Penn regularly reinvented himself and photographed in diverse genres and like Richard Avedon he operated simultaneously in another branch of

A still life shot by Penn for a 1970s Calvin Klein print advert.

commercial photography – advertising. In 1953 Penn opened his own studio, working for major advertising clients and becoming one of the most successful photographers in the field. He married Lisa Fonssagrives, his favourite model in 1950. Using his portable studio he travelled widely, making ethnographic studies, and he shot a series of experimental nudes from 1949 to 1950. Fearing adverse public reaction to the latter, he hid the prints in a box, where they stayed until exhibited 30 years later. These rounded nudes have been described as 'a kind of voluntary kamikaze attack by Penn against his public identity as a famous photographer', such was their contrast to the slender forms of his fashion models.

Penn produced many still-life studies, using everyday and found objects, from shells to cigarette butts. Each is painstakingly arranged, just as his fashion compositions and portraits are, displaying great clarity of vision.

Helmut Newton

Turning the convention of haute-couture photography on its head, Helmut Newton's work was controversial and, beyond all argument, changed the genre of fashion photography past recognition.

Born 1920, Berlin, Germany
Importance Introduced explicit eroticism to haute couture
Died 2004, California, United States

Helmut Neustadter was 12 when he bought his first camera. He had wanted to be a reporter in the mould of Weegee, but left school to become apprentice to fashion photographer Yva. In 1938, in the wake of Kristallnacht, his Jewish parents urged him to leave Germany and he set off for China, stopping off in Singapore, where he remained for two years working as a reporter and portrait photographer. In 1940, he moved to Australia and joined the army, where he served until 1944; he then changed his name to Newton and took Australian citizenship. In 1948, he married June F Brown, the actress June Brunelle, and opened a studio. In 1956 his work illustrated an Australian fashion supplement for *Vogue*, as a result of which he was contracted for a year to British *Vogue*. He did not complete the contract, but went instead to Paris, in 1957, and worked for both French and German editions. From 1961, he began a long career with French *Vogue* and *Harper's Bazaar*, among others.

The photographing of haute couture had a classic and elegant tradition, which Newton set about demolishing. He was working in the early years of sexual liberation and produced erotic, sexualised images, highly stylised and staged, frequently involving sadomasochistic and fetishistic props and poses. His models exhibited a mixture of beauty and statuesque power, and nudity often featured in the work. The essence of his style was to link fashion with wealth and sex. Newton staged his work against backgrounds of grand hotel

interiors and the Paris streets at night, each image a sexually charged tableau, highly polished and produced. The level of craftsmanship evident in his work, combined with its daring, established him internationally.

In the mid-70s, Newton began to concentrate on exhibiting and publishing. In 1980 he produced his 'Big Nudes' series featuring beautiful naked Amazons printed in black and white at awesome life size. The work attracted huge

Portrait of Eva Herzigova at the Cannes Film Festival by Helmut Newton (1996).

attention, lauded by Newton's admirers and damned in equal measure by women's liberationists. It was widely exhibited, on occasion providing protests and physical attacks against the gallery involved.

Another landmark in his career came in 1999, when Taschen published *Sumo*, the biggest and most expensive book production of the century. Published in a 'limited' edition of 10,000, each was signed and numbered by Newton. Its 464 pages, measuring 70x50cm (271/2 x 191/2in), weighed in at an eye-watering 30kg (66lb) and it came with a metal viewing stand designed by Phillipe Starck. The original selling price was $2,500, although dealers now offer copies at anything up to $25,000.

Richard Avedon

Although always carefully staged and composed, Richard Avedon's style looks refreshingly simple and has been widely adopted in both fashion and portraiture. Although it was fashion photography that provided his main source of income, his great love was portraiture, and this was to produce his personal style.

Born 1923, New York, United States
Importance Widely acclaimed fashion and portrait photographer
Died 2004, Texas, United States

After a short stint studying philosophy at New York's Columbia University, and while still in his teens, Avedon joined the US Merchant Marine where he worked in the photography section. Using a Rolleiflex camera his father had given him, he made portraits of sailors for their service records. In 1944, he began work as an advertising photographer for a store and studied under *Harper's Bazaar* art director Alexey Brodovitch at the New School for Social Research, New York. It was Brodovitch who 'discovered' him and, in 1945, when Avedon was still 21, his first fashion pictures appeared in the magazine, where he then became chief photographer and was to work for 20 years. In 1946 he set up a studio in New York and from 1950, in addition to his work for *Harper's Bazaar*, took commissions from *Life* and *Look* magazines. From 1966 he became a regular contributor to *Vogue* and was its principal photographer until 1988.

Avedon became one of the most important photographers of his generation. He worked with graceful, elegant models, who could move like dancers and would laugh and express themselves for his camera; a refreshingly different approach from the static poses adopted in most fashion work of the time. Much of his work was made in the studio: not only did this allow for careful control of lighting, but it suited his favoured style of shooting against plain white, or neutral grey backgrounds.

This extended to even taking his 'studio' out on location. During the six years from 1979, on commission from the Amon Carter Museum in Texas, Avedon took a 'light tent' portable studio around the American West making portraits of cowboys, drifters and others he met, using a large-format camera and his trademark plain white background. Some 125 portraits in the Avedon style were made, his subjects isolated from their environment looking squarely at the camera and, in that isolation, demanding attention. These folk are not rehearsed in professional portraiture and their somewhat 'fish out of water' vulnerability is revealing. The large negatives allowed for big, detailed prints, something else for which he became known, and the work was published and exhibited as 'In the American West'.

This was a milestone in portrait photography, and its mode of execution has been repeated by others. Of Avedon's various projects, 'In the American West' is widely considered to be his most important.

Final preparations for a 2008 exhibition in Berlin of Avedon's work.

David Bailey

David Bailey was the first 'celebrity' photographer, his work shaping the face of 1960s' British popular culture. His trademark portrait style is tightly composed, concentrating attention on the face, with the top or sides of the head sometimes cropped off. The style was adopted by many others in the field, and Bailey's images remain icons of their era.

Born 1938, London, England
Importance A major force in defining London in the Swinging Sixties

Bailey was born in East London just before the Second World War. After national service in the Air Force, he decided to pursue a career as a photographer, but failed to secure a college place owing to his poor school record. He began work as a photographer's assistant instead, becoming assistant to John French, one of the greatest fashion photographers of the day. He also worked freelance, and in 1960 enjoyed another important break, when he became contracted to *Vogue* magazine.

Bailey was of a generation of photographers working in 1960s' London and swinging along with it. He and his contemporary, Terence Donovan, were the first celebrity photographers, as well known as the people they photographed. Indeed, among a British public largely ignorant of those plying their trade behind the camera, Bailey was the one you would expect them to come up with when asked to name a professional photographer. His notoriety was exploited by Olympus Cameras in its humorous long-running 'David Who?' television adverts, and served to make Bailey even more famous. Antonioni's 1966 movie *Blowup* starred a London fashion photographer played by David Hemmings: the film painted a lurid picture of Swinging Sixties' London and the life and peccadilloes of its central figure; there has never been much doubt on whom its central character was based.

Bailey's early work was shot on the square-format Rolleiflex, a twin-lens reflex camera producing 6x6cm negatives. He enjoyed the fashion work as much for his beautiful subjects, many of whom he dated, as for the work itself. His four wives have included actress Catherine Deneuve, the model Marie Helvin and Catherine Dyer, his current wife who is also a model.

Catherine Deneuve and David Bailey ride in the back of a London taxi, 1966.

His style is essentially simple and therefore timeless. As well as fashion he has photographed many portraits, his subjects ranging from beautiful women to the notorious London gangsters, the Kray Twins, via rock stars, dancers and actors; all of them friends and acquaintances.

In common with many contemporaries he has turned his hand to directing commercials and videos, and went into publishing briefly with the style newspaper *Ritz* in the mid-1970s, in collaboration with David Litchfield. Several books of his work have been, and continue to be, published.

Although David Bailey made his name as a fashion photographer, his portraits record the culture and ethos of the era in which he came to fame. And it may very well be that it is this work that turns out to stand the test of time and for which he will be remembered.

ROCK-AND-ROLL YEARS

By the 1960s the world was beginning to recover economically and psychologically from the debilitations of the Second World War. A new youth culture had began to emerge with the advent of rock-and-roll in the 1950s, but even then there was little sign of youth fashion: once old enough to graduate from short trousers you wore pretty much what your parents did. Confidence was returning as shortages brought on by war eased and bombed cities were rebuilt, and the young generation that grew up during the war began to demand and enjoy new freedoms.

There was a creative explosion in new popular music, alien to those who had fought in the war, custom-built for youth, and with it came clothes by which the young could mark themselves out as belonging to a different generation – 'My Generation' as the hit single from The Who would have it. In addition, the introduction of the contraceptive pill brought the possibility of sexual freedom and, to a background of The Beatles and the Rolling Stones, the Sixties began to swing.

This new youth market for fashion brought about an inevitable change in its photography. Previously magazines like *Vogue* and *Harper's Bazaar* had ruled the roost, using elegant, often upper-crust models to promote Paris haute couture; clothes that most readers could only aspire to. The 1960s saw the emergence of retail chains and small boutiques – Biba and Chelsea Girl – selling designs affordable by any fashionable young person, and magazines such as *Nova* and *Honey* appeared, targeted firmly at the youth market. London became the swinging centre of fashion and popular music, youth culture in general, and a group of young photographers rose through the ranks to promote and record it.

David Bailey, Terence Donovan and Brian Duffy were the pre-eminent trio of London-based fashion photographers of the Sixties. They were born within a few years of each other and belonged to the same generation as those they were photographing for: Bailey was contracted to *Vogue* at just 20 years old. They used sexy young women as models, rather than elegant debutantes, names that would enter popular culture such as Twiggy and Jean 'The Shrimp' Shrimpton. Models had rarely previously become celebrities, but their integral role in the new youth culture changed that; and the young photographers who created their public personas were as central to the scene as the pop stars and rock-and-rollers in whose circles they moved. And while they partied their way around the capital, they took their photography seriously. As Bailey has written:

> *'They were the enfants terribles. They dominated the scene.'*
>
> Don McCullin on Bailey, Donovan and Duffy

I have always considered fashion photography to be as important as any other form of photography. The best work becomes a social document as well as an art form. It is a record of the way people wanted to look at a certain time.

And although fashion is ephemeral, Bailey is certainly right. The look and feel of the Swinging Sixties is imprinted on the historical record by his work, and that of his contemporaries, made during this revolutionary decade.

The History Man
Francis Frith

Early photographers fell broadly into two groups: gentlemen artists and scientists, and tradesmen. The former were dedicated to experiment and progress, the latter were intent on making money. Francis Firth had a foot in both camps. He was a Quaker and a moral man, with the firm Victorian belief in the worthiness of knowledge, but he was also an astute businessman and held no qualms about the generation of profit.

Born 1822, Chesterfield, England
Importance Created a vast photographic enterprise based on the thirst for knowledge
Died 1899, Cannes, France

Frith combined his talent as a photographer with his love of travel, undertaking three tours of Egypt and the Middle East between 1856 and 1859. This was not a straightforward exercise. He was photographing on 16x20in glass plates, so the camera was cumbersome, and the heat and bright light were far from ideal conditions for coating and processing the plates. This saw him sheltering in temples and caves to produce his negatives. The curiosity of Victorian times provided a ready market for his prints, and he sold albums of them with descriptions and dialogue, and stereoscopic views. 'The Sphynx and Great Pyramid, Geezeh' is typical of both his subject matter and his approach to photographing it. His viewpoint has been chosen with care to show both to best advantage. The scene is sunlit from the side, giving a better, three-dimensional, sense of mass and modelling than if it had been coming from behind the camera.

Frith's topographical coverage was comprehensive. He travelled next through Europe and Britain, steadily building up what probably amounts to the first photo library. F Frith & Co was set up to produce and distribute the work and, in order to realise what was rapidly becoming an enterprise of huge ambition, Frith employed

'The Southern Brick Pyramid of Dahshoor, from the West', c 1860s. Typical of Frith's work, human figures give an impression of the scale of the structure.

several other photographers to contribute to the archive with some, such as the highly regarded Francis Bedford, selling him existing material. The company operated on a prodigious scale: at its height some one million images were stocked in 2,000 shops. Similarly, the number of publications was huge. Themed series were produced: *Frith's Photo-Pictures* featured original prints of a specific region and included folios of the 'English Lake District', 'Swiss Views' and 'From the Lands of the Bible'. The company became the country's largest supplier of architectural views, landscapes and postcards. Between its formation in 1860 and the time the company closed, in 1971, it had amassed around 300,000 photographs, many of them added after Frith's death.

Relaunched as 'The Francis Frith Collection' by one John Buck in 1977, it remains one of the few significant collections of historical photography not to have fallen into the hands of one of the main stock libraries that have grown by gobbling up smaller outfits over recent years.

Edward Weston

Edward Weston photographed the shape and form of nature in its many guises, in particular still lifes, nudes and landscapes. There is a seamless relationship in his rendering of these otherwise apparently unrelated genres, which he identified as: 'the universality of basic form'.

Born 1886, Illinois, United States
Importance Produced landscapes and studies of natural form, unsurpassed in their revelation and beauty
Died 1958, California, United States

At age 16, Weston's father gave him a Kodak camera. He began to teach himself photography, working on portraits, followed by postcards made in Los Angeles, and then, in 1908, he studied at Illinois College of Photography in Chicago. He moved to California and opened a studio in 1911, employing a highly successful pictorial style using soft-focus lenses to make portraits of ballerinas and film stars. He became a virtuoso printer, a skill that later combined with his investigation of natural forms – shells and vegetables – to produce images of great beauty and simplicity. It was at this point that he set aside the romantic style of pictorialism in favour of 'straight' photography.

This concept of straight photography was at the heart of 'Group f/64', which Weston co-founded with Ansel Adams, and others, in 1932. Members worked with large-format negatives and small lens apertures to produce maximum depth of field and detailed sharpness in their photographs. Weston never enlarged his images, all were contact prints made from the camera negative; and by not employing the intermediate optical process of the enlarger, he retained the highest possible sharpness and detail in his prints.

His landscape photographs of sand dunes are particularly well known, as are his studies of rock formations. The light rakes the undulations, ripples and rounded edges, revealing their unblemished

form and textures. This same, studied use of light appears in his abstracted images of sea shells, wrinkled cabbage leaves and waxy peppers – even his female nudes – and through it he celebrates the varied, yet related, forms of nature.

In 1937, a time when other photographers of note – including his friend Dorothea Lange – were documenting the effects of the Great Depression (see page 42), Weston was awarded a Guggenheim Fellowship, the first photographer to receive one. He had applied to the Guggenheim Foundation the previous year, already famous in his own right and widely exhibited, making clear his proposal was not social documentary in nature, but a wish to continue with the landscape series he had begun on moving to Carmel, California, in 1929. The fellowship provided financial backing for over 32,000 km (20,000 miles) of travel and the making of over 1,400 negatives, the most prolific period of his career. Wishing this important work to remain together, be preserved and seen, he gifted 500 prints to the Huntington Library in southern California, in whose collection they remain today. A full archive of his work is held by the University of Arizona in the Center for Creative Photography. Weston stopped photographing some 10 years before he died, his career cut short by the onset of Parkinson's disease.

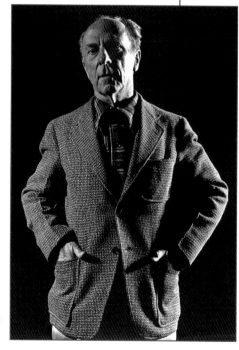

A studio portrait of Edward Weston taken in 1948.

Ansel Adams

Like many photographers, Ansel Adams began making pictures when he was young. He first took up photography at 14, during one of his regular family holidays in California's spectacular Yosemite Valley, a location he would return to many times and where many of his most famous images were made.

Born 1902, California, United States
Importance Made beautifully crafted black-and-white prints celebrating the grandeur of landscape
Died 1984, Indiana, United States

Adams knew and worked with many of the great names in the history of American photography, and it was a meeting with Paul Strand, in 1930, that inspired him to make a career in the medium. He began along the path to becoming one of the most famous landscape photographers in the world, and one of the finest black-and-white printers, by forming Group f/64 with Imogen Cunningham and Edward Weston in 1932, themselves both giants of the medium.

Group f/64 was a camera club of sorts. Its members shared a philosophy of photography, a philosophy you might call 'slow' photography, carefully considered and deliberate. F/64 is the smallest aperture setting generally found on the lens of a large-format or 'view' camera. This, on the one hand, provides maximum depth of field in the image (see page 104), and on the other requires a long (slow) shutter speed and therefore, a static subject. Landscape provides just that, and the large-film format of the view camera, in combination with great depth of field, is ideal for capturing the almost infinite detail of a natural scene. The view camera takes time to set up and use, so all elements of the 'slow' philosophy tie in.

Key to his success and enduring reputation was Adams' collaboration with Fred Archer in the formulation of the Zone System. The system was devised to calculate the exposure needed to produce

'Glacier National Park in Montana', taken by Ansel Adams in 1941, is typical of his striking images of the American landscape.

the optimum negative, one in which all the required tonal values from shadow to highlight would be recorded, and so give the photographer a flying start on entering the darkroom to make a print. The 'zones' were designated 0–10: 0 representing pure black and 10 white; zone 5 being mid-grey. For guidance, Adams set out elements of a typical scene against each of the zones to be recorded: for instance, zone 8 represents 'lightest tone with texture, textured snow'. The system is still widely used today by 'slow' landscape photographers.

During his career, Adams produced more than two-dozen albums dedicated to the breathtaking landscapes of American national parks. His painstakingly crafted original prints change hands for small fortunes. Adams' work is the inspiration for photographers who continue to carry bulky, fiddly and old-fashioned camera equipment into the wild and slowly set about creating their art; his Zone System for exposure is their means of aspiring to make prints as fine as he did.

ARTISTS AND ALTERNATIVE PROCESSES

'Alternative processes' are techniques for making photographic prints that hark back to the nineteenth century, yet are still in use by photographic artists today.

In an age when the ubiquity of digital photography has made the continued use of film cameras seem quaint and outdated, it might seem especially odd that printmaking processes from the 1840s and 1850s still have a following. Once flexible film and enlargement onto sensitised paper had become the standard way of making prints, the older techniques became known as 'alternative' processes. They no longer had a place in the mass market and disappeared from public view, but they did not die out entirely.

The reason for this apparent anachronism is in large part a response to the essential nature of the negative/positive process and the reason for its success – its reproducibility. Although most of the pioneers of photography were scientists, many of its early exponents were artists, and it has always been a medium of artistic expression for those who practised it, even if this has only begun to be accepted by the art establishment in recent times (see page 114). Over the years, improvements have been made in equipment and materials to make photography, an essentially mechanical process, ever more precise and predictable: in its nature, therefore, at odds with artistic practice. And that explains the appeal of the early processes to the artist.

In its earliest days photography was acknowledged to be a combination of craft and science, if not art and science. The enlarger had not been invented and so photographs were made by contact printing negatives onto light sensitive paper to make a positive. The exposure of the print through the negative might use daylight, or an

ultraviolet lamp for shorter exposure times. Various processes existed, each involving different chemistry, but all following a very similar procedure. A big part of the craft element in these processes comes from the photographers coating the printing papers themselves by hand. It's a field open to experimentation both in the production of the negative to produce certain qualities in the final print, and in the coating of the paper with variations in proportions and concentrations of the chemicals involved and their development. As a consequence, the resulting prints show variations, just as would be seen in etchings or engravings pulled from the same plate. The same high-quality papers are used as in printmaking and watercolours, which further enhances the allure of the finished print.

'Character, like a photograph, develops in darkness.'

Yousuf Karsh

A factor of these processes is that most are extremely permanent, an important quality when selling work to collectors. Conventional silver-halide photographs are prone to attack by environmental pollution and fading from prolonged exposure to sunlight, unless they are treated with chemical toners, such as selenium or gold, to convert the image into something more inert. Many of the alternative processes use chemicals that are relatively inert to start with: a prime example would be the platinum print. A fine platinum print exhibits the fullest tonal range while retaining detail in both shadows and highlights and can be very luminous and beautiful, rewarding lengthy study. The image is extremely permanent and because the platinum salts required for the process are understood to be expensive, the prints can command a high price.

Salt prints, daguerreotypes, cyanotypes, calotypes, gum prints and platinum prints are all photographic techniques from the century before last; as such they belong in history. Yet the craft skills required to make them and the inherent beauty and variability of the end result see the processes still in use today among photographic artists.

Bernd and Hilla Becher

During the latter half of the twentieth century German photographers Bernd and Hilla Becher epitomised the practice of using photography in systematic surveys to compile visual material in comparative form with a view to preserving it for posterity.

Born (Bernd) 1931, Siegen, Germany; (Hilla, née Wobeser) 1934, Postdam, Germany
Importance Influential pioneers and teachers of conceptual photography
Died (Bernd) 2007, Rostock, Germany

The Bechers met while studying at the Düsseldorf Art Academy and began their lifelong photographic partnership in 1959. They married in 1961 and their first exhibition was held in 1963. They travelled in Europe, and then the US, recording industrial architecture. By adopting a systematic approach, photographing on large format in flat light, square-on to the structure, often from a slightly elevated viewpoint, the project built into a comparative inventory of functional architecture, a 'typology' of industrial form and structure. They photographed blast furnaces, grain elevators, gasometers and cooling towers; structures that were disappearing as quickly as they could photograph them.

Carefully composed and printed so that the images differed only in their specific detail, the work was presented arranged into grids by type, so inviting comparison and creating a strong presence on the gallery wall. It is the work in its totality and presentation that is significant, rather than individual images.

The Bechers became famous not as photographers, but as part of the conceptual art movement of the late 1960s and early 1970s. The formal rigour of the work and its presentation was seen as minimalist and conceptual, a comparative sculptural study. Indeed, their work represented Germany in the 1990 Venice Biennale and was awarded a Golden Lion – for sculpture.

This interpretation of their practice was acknowledged by the title of their first book: *Anonymous Sculptures: A Typology of Technical Construction*, published in 1970. As the work amassed, their publications concentrated on single types of structure: between 1988 and 2001 they produced seven books in this vein, beginning with *Water Towers* (1988) and *Blast Furnaces* (1990).

In 1975, the Becher's work was shown as part of the 'New Topographics' exhibition alongside that of Robert Adams, Stephen Shore and others, a show of great importance that was to influence a whole generation of photographers. Much of their enormous influence came through their teaching at the Düsseldorf Art Academy where, from 1976, Bernd was a professor. The work of their students, widely referred to as the 'Düsseldorf School' of photography, is also sometimes known as the 'Becher' school. Not since the days of the old masters has it been common to refer to an institution by the name of its teacher.

Bernd and Hilla Becher 'Winding Tower', taken in Calais, France, in 1967.

Robert Adams

Robert Adams came late to photography. He had already had a career as a professor of English when, in 1967, aged 30, he began freelance photography, to which he switched full-time in 1970. For 40 years he has been photographing the landscape of the American West, in particular in his home state of Colorado.

Born 1937, New Jersey, United States
Importance
Has documented the despoiling of the American West for 40 years

His work contrasts with that of the preceding generation, typified by his namesake Ansel Adams. Whereas the latter specialised in portraying nature's grandeur, Robert Adams' pictures are quiet and contemplative and requiring of contemplation. And while he avoids the sentimental pictorialism of the other Adams, he does not go to the opposite extreme of raw polemic; he shows the beauty of landscape, its edge lost to the hand of man, picturing how things are, how they were, and how they might be.

His work first came to prominence with the publication of *New West: Landscapes Along the Colorado Front Range* in 1974. In it he documented the way in which the grace and beauty of the landscape had been diminished by urbanisation – roads, shopping malls and trailer parks. He featured in the landmark exhibition 'New Topographics', which brought together 'photographs of man-altered landscapes' and was shown at George Eastman House in Rochester, New York, in 1975. Here, the work was claimed to be emotionally neutral, objective and without opinion; the style was 'no style', the antithesis of the elder Adams and his f/64 Group colleagues. On the other hand, the influence of Robert Adams – and Bernd and Hill Becher and Stephen Shore, who also featured in the exhibition – has been such, that this 'absence' of style is recognisable in much of the work of today's young photographers.

Over the years, Adams has photographed the unerring creep of man into the pristine landscape with a cool and apparently artless vision. He has published more than 20 books, including volumes of critical writing. In a 1983 essay written for Daniel Wolf's book *The American Space* he wrote: 'Landscape photography can offer us, I think, three verities – geography, autobiography and metaphor. Geography is, if taken alone, sometimes boring, autobiography is frequently trivial and metaphor can be dubious. But taken together … the three kinds of representation strengthen each other and reinforce what we all work to keep intact – an affection for life'.

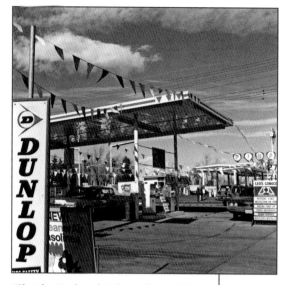

'Sheridan Boulevard, Lakewood' (1970) by Robert Adams

In his 2005 book, *Turning Back*, Adams marked the 200th anniversary of Lewis and Clark's exploration for the Northwest Passage, by retracing their steps. The original expedition had been inspired by commercial greed and Adams photographed two centuries on, recording on the one hand the enduring marks of that doomed enterprise and, on the other, what remains unharmed, by accident or design, or just by plain good fortune.

The work of Robert Adams was among the first to highlight the carefree way in which America's West was being tarnished. The work is apposite in both its observation and its timing, and all the more persuasive because it prods but doesn't scream.

The New Colour Photography

Stephen Shore

Stephen Shore is said to have been given a darkroom kit at the age of six. When only 14, he sold three prints to Edward Steichen at the Museum of Modern Art , and by his late teens he was photographing the goings on at Andy Warhol's Factory and the Velvet Underground in rehearsal. These precocious activities aside, it is for his influence over colour photography, from the 1970s on, that Stephen Shore is known.

Born 1947, New York, United States
Importance Established the credentials of colour photography in art

Shore's photographs featured in the 'New Topographics' exhibition of 1975, and the show proved to have a huge influence on contemporary photography. His was the only colour photography included in the exhibition, black and white being the ubiquitous art-photography medium of the day. Yet nowadays, if an equivalent show were to be staged most, if not all, would be in colour.

Between 1972 and 1978, Shore undertook a series of road trips across the US by car, photographing small-town America and landscapes in colour, inspired by Walker Evans' seminal book *American Photographs*. At this time colour was somewhat frowned upon. By now he was working with a 10x8in view camera and, initially, he made his prints by contacting the negatives onto the paper. In this way he retained a close relationship between the print and the highly detailed negative the large format produced. Shore has become one of a trio credited with 'inventing' colour photography in the 1970s, the others being William Eggleston and Joel Meyerowitz.

His pictures featured the same visual iconography of the American urban landscape as those of Walker Evans, Robert Frank and others: cars and parking lots, motels and diners, road signs and telegraph poles, but with colour as an additional important layer. And while the black-and-white work of his contemporaries had

modernised landscape by turning it away from its sentimental pictorial tradition in the direction of documentary, by establishing the validity of colour, Shore had made it no longer possible to continue photographing in black and white and still produce pictures that appeared to be modern, that is, of their time.

Although Robert Frank had famously remarked that: 'black and white are the colours of reality', Shore's work reeked of reality, and because his pictures were in colour. Stephen Shore's work was shown alongside that of Robert Adams in 'New Topographics': if Adams' images are quietly judgmental, those of Shore would barely whisper were it not for the reality of colour. His success in achieving this, and turning the tables on black and white photography, has shaped much of modern photographic practice.

The bright lights of Las Vegas. Taken in black and white, the impact of such an image would be lost.

Brassaï

Photography is wholly reliant upon light, so it is ironic that it was a fascination with Paris by night that inspired Brassaï to take up the medium. It was André Kertész who made him aware that photography was possible at night and in 1930, determined to capture his nighttime perambulations and the city's secret sights, Brassaē became a photographer.

Born 1899, Brassó, Hungary
Importance
Photographed the seamy side of nighttime Paris
Died 1984, Beaulieu-sur-Mer, France

Gyula Halász was born to a Hungarian father and Armenian mother. He studied fine art in Budapest as a young man and, in late 1920, travelled to Berlin where he became acquainted with László Moholy-Nagy, and the painter, Wassily Kandinsky. In 1924 he moved to Paris, where he remained for the rest of his life.

He worked as a journalist, making friends with the writer Henry Miller and poet Jacques Prévert and, in 1925, adopted the name Brassaï, meaning 'from Brassó'. The following year, through an art-critic friend, he met photographer and compatriot André Kertész. Fascinated by the secret life of Paris by night, Brassaï would walk the mysterious city streets for hours at a time until he knew the place like the back of his hand.

He was one of the first to photograph the city at night, quite probably because the equipment and materials of the day weren't really up to the job. The camera was bulky and had to be set on a tripod – not at all suited to the candid street photography that would come in later years. And the magnesium flash lighting gave the game away, too. So when, as they often did, his photographs featured people, Brassaï had to work as a director, gaining the trust and cooperation of his subjects and getting them to hold the pose. He photographed the city's streets and their nocturnal inhabitants:

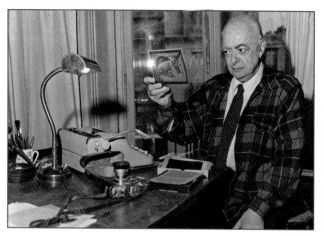

Brassaï. Henry Miller called him 'The Eye of Paris'.

prostitutes and their clients, drinkers, dancers and entertainers, lovers, strippers, transvestites and homosexuals, opium smokers, restaurant diners and music-hall goers. He made many photographs of the graffiti he found on walls, each a little story in itself: a series of these appeared in the surrealist magazine *Le Minotaure* in 1933. In his later years, having ceased photographing to return to drawing and sculpture, some of his graffiti pictures were made into tapestries.

Although Brassaï enjoyed a celebrated career of more than 30 years, his seminal work – the nocturnal photographs of 'secret' Paris – was produced early on. *Paris de Nuit* (*Paris by Night*) was published in 1933, and remains a milestone in photographic publishing. He photographed what his friends, Henry Miller and Léon-Paul Fargue, the poet, wrote about; indeed they accompanied him regularly on his nighttime wanderings.

Brassaï worked for the famous magazines – *Harper's Bazaar, Picture Post, Verve, Lilliput* – often contributing portraits of his famous artist and writer friends. And, although these fine portraits remain important documents of the European art world of his day, it is for his groundbreaking photographs of a seamy Paris by night that he will continue to be admired.

Bill Brandt

Bill Brandt came to prominence with his urban documentary work on London and England's north and midlands, also producing important work on landscapes, portraiture and the nude.

Born 1904, Hamburg, Germany
Importance One of Britain's most important photographers
Died 1983, London, England

German-born Brandt trained as a photographer in Vienna. Through a friend, he met the poet, Ezra Pound, and made his portrait, in return for which Pound introduced him to Man Ray in 1929. Brandt assisted in Ray's Paris studio for three months, after which he travelled in Europe, settling in London, in 1932.

In his book, *The English At Home* (1936), Brandt produced a document of British society, an unusual approach for the time, which is notable for his considered and witty juxtaposing of images. The work records and contrasts the everyday doings of the upper classes at play, their below-stairs servants, and London's working-class East Enders. By carefully sequencing the pictures to reference each other Brandt had developed a montage style of storytelling; he began working for *Weekly Illustrated* magazine.

In 1937, he began work with a new magazine, *Lilliput*, which set great store by the use of photography; the same publisher launched *Picture Post* in late 1938, on which Brandt worked from its inception. He travelled to the industrial towns and cities of the English north and midlands where he documented the lives and living conditions of coalminers. He worked indoors and out, day and night: by the 1930s, films had become fast enough to allow work at relative speed in low light, further aided by the invention of flash.

Brandt produced several bodies of work on London, its streets and buildings as well as life behind the doors of pubs and ordinary homes. Inspired by Brassaï's *Paris by Night* of 1936, Brandt published

A Night in London in 1938. *Camera in London* followed 10 years later. In 1940, he was commissioned by the Ministry of Information to photograph London's air-raid shelters, picturing the masses huddled in the underground, shop cellars and under railway arches. In the following year he photographed important endangered buildings for the National Buildings Record. During the war he also made an extensive study of the Bournville Estate, set up by chocolate maker George Cadbury, in 1900, for his workers. These pictures have recently been published in book form.

As well as his many urban studies, Brandt photographed landscapes and figures from the arts, and is particularly well known for his later nude studies, photographed with a perspective-distorting wide-angle lens, and printed in his trademark high-contrast style.

Through publication in mass-circulation picture magazines, Bill Brandt's historical documents of Britain's cities and people around the time of the Second World War, executed in a graphic style through an artist's eye, made him one of the most significant British photographers of his day.

'Man In Pub' by Bill Brandt, 1946

Robert Doisneau

Although Robert Doisneau was a staff photographer at *Vogue* magazine for some years, it was the resonant and humorous pictures he took of Paris street scenes that brought him to prominence.

Born 1912, Gentilly, France
Importance His pictures have come to define Parisian life
Died 1994, Paris, France

Doisneau trained as a lithographer, but while still in his teens taught himself photography and adopted it as his career. In 1931, he became assistant to André Vigneau, one of the first advertising photographers and, in 1934, joined the staff of Renault as an advertising and industrial photographer. He worked there until 1939 when he was sacked for poor timekeeping.

Doisneau decided to become a freelance photojournalist and joined the Rapho agency, but after only a few assignments the Second World War intervened and he entered the French army. He continued with his photography during this period, producing several series of postcards for sale.

He was of a generation that produced many photographers of note who were working in Paris and photographing in the streets. Inspired by Eugène Atget a generation earlier, these included Kertész, Cartier-Bresson and Brassaï. Doisneau wrote: 'The marvels of daily life are exciting; no movie director can arrange the unexpected that you find in the street.' As it happens, that statement was to find him out. He photographed intimate moments of everyday life, in the streets, cafes, shops and bars, children at play, each recording one of those 'unexpected' telling moments.

His most famous picture, 'Kiss in the Town Hall Square', is a candid shot of lovers embracing, unheeded by passers by, quintessentially, romantically French. It was made in 1950 (he was under contract to *Vogue* between 1949 and 1952) and over the years

will have sold in many thousands as postcards and posters. With its untidy composition it is clearly snatched, 'shot from the hip', or is it? Naturally the identity of the couple was unknown but, in 1993, Denise and Jean-Louis Lavergne – rather late in the day some would say – took Doisneau to court under French privacy law for taking the picture without their permission. The action failed, but only because Doisneau was able to prove that he had staged the shot using models. This will not have enhanced his reputation as a street photographer, but it increased the fame of the picture and, in 2005, the woman in it, Françoise Bornet, auctioned the print Doisneau had given her at the time for a tidy 150,000 Euros.

Doisneau was prolific and dozens of books of his work were published and many exhibitions held around the world. His work

was, and continues to be, widely reproduced in magazines, on postcards and as posters. Probably more than any other photographer, his pictures have given the wider world its understanding of what Parisian life and the people of France are all about.

Robert Doisneau signs a print of one of his famous portraits of Picasso.

WHEN THE CAMERA LIES

The assertion that 'the camera never lies' comes from photography being a mechanical recording medium. The camera simply sees what is in front of it, whereas a painting is an interpretation. But, in practice, the camera always lies, and so, especially, does the photographer.

The camera does not see as we do. It records an instant, while we see in real time; the camera's record will not match our perception. We see with two eyes stereoscopically, which is how we perceive depth; the camera expresses distance through depth of field (the zone of sharpness) and by perspective, both of which change according to the focal length of the lens and its aperture. In seeing we look about; the camera takes a fixed frame in which subject matter is included or cropped out. Indeed the 'truth' of a photograph is affected as much by what is excluded as by what it contains. So, at best, photographic truths are partial.

Photography was less than 15 years old when Oscar Gustave Rejlander began to experiment with combination printing, combining elements from several separate negatives in a single print. Creating his most famous work in 1857, 'The Two Ways of Life' he seamlessly combined figures from 32 individual negatives in a massive allegorical tableau. His colleague Henry Peach Robinson employed a similar technique, though not on such a grand scale, combining separately posed figures in his prints of allegorical scenes. Both photographers made fictions, but not with the intention of deceit: they were exploiting the possibilities of the darkroom to create images that would have been difficult to capture in a single camera frame.

The early years of photography coincided with a rise in popularity of spiritualism. It attracted followers eager to believe, and the ignoble motives of some of those involved saw a proliferation of

'spirit' photographs purporting to show mediums in trance and the formation of 'ectoplasm' emanating from them. Today the pictures would not be given a second glance, but in those early days there was still a willingness to trust the camera.

The documentary value of the photograph – both as stills and films – has been used to back up eyewitness accounts of all manner of doubtful phenomena, including the Loch Ness Monster and Bigfoot. A particularly fertile genre is the unidentified flying object. Such photographs can be divided into three groups: deliberate fakes; unusual atmospheric phenomena and camera faults; and the as yet unexplained. Camera and film-processing faults have been responsible for thousands of 'paranormal' photographs, as have fleeting effects of light and shadow, unnoticed by the photographer at the time of taking.

Even by the mid-twentieth century the objectivity of the photograph was still considered powerful enough for the then Soviet Union to airbrush discredited politicians from official photographs, to suggest they had never existed and to rewrite history. Then came digital photography.

Now no one trusts a photograph. Through familiarity with digital images and the software to manipulate them, every photograph that deserves a sceptical response gets it, be it a news picture or a celebrity portrait. The use of retouching in editorial and advertising photography to correct technical imperfections has long been common practice. But the power of modern technology is such that the ease with which the appearance of the subject can be 'improved', and the sometimes extreme extent to which this is carried out – in particular on the covers and inside pages of women's magazines – has given rise to a backlash of opinion. And as if to make the point, 'to photoshop' has entered the language as a verb.

'All photographs are accurate. None of them is the truth.'
Richard Avedon

Street Children
Helen Levitt

Helen Levitt took up photography to record the creativity of the children of the streets around her home in New York. And, by photographing them without their knowledge, she created a unique body of work.

Born 1913, New York, United States
Importance An 'invisible' photographer of New York's underprivileged youngsters at play on the streets

Levitt was born, and grew up, in Brooklyn. She had dropped out of high school, but discovered photography through an exhibition of the work of Henri Cartier-Bresson and taught herself while working for a commercial photographer. In 1937, she bought a Leica and began to make photographs of children on the streets of Harlem and Brooklyn. The small, quiet, inconspicuous black camera allowed her to photograph without being noticed, sometimes using a right-angled viewfinder.

Photographing in this way, Levitt was 'invisible' and able to capture the natural interactions of the youngsters in their urban playground. It would be a hazardous business to attempt to take such pictures nowadays. She photographed the chalk drawings and the children who made them over a period of many years and they were published eventually in *In the Street: Chalk Drawings and Messages, New York City, 1938–48*, in 1987.

From 1938 to 1939, Levitt studied under Walker Evans and, in 1943, she exhibited 'Children: Photographs of Helen Levitt', curated by Edward Steichen, at the Museum of Modern Art (MoMA). The popularity of the show saw her begin to receive commissions for press and documentary work. Her first book, *A Way of Seeing*, did not appear until 1965, although it had been put together as early as 1946; it carried a foreword by James Agee, a writer who had collaborated with several photographers, and with whom Levitt had made two documentary films during the 1940s. Like Paris, the streets of New

York have been rich hunting grounds for photographers, and like her peers, Levitt's love of walking those streets with open eyes led inevitably to the work.

Her career has spanned a remarkable 70 years. In 1959 and 1960 she received awards from the Guggenheim Foundation to make colour photographs on her familiar streets. Much of this work was tragically lost when her apartment was burgled in 1970, but what remained, along with later work, was published in *Slide Show: The Colour Photographs of Helen Levitt* in 2005, introduced by John Szarkowski.

Helen Levitt's legacy is a unique body of work that records the everyday activities of children from some of New York's poorer neighbourhoods, in the only playground available to them, photographed as if no photographer were there.

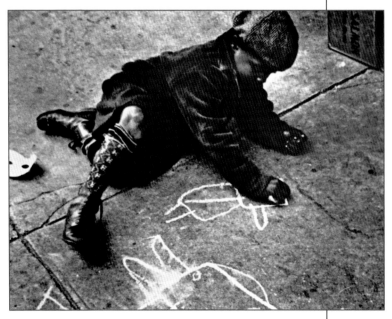

Levitt was teaching art to youngsters in New York and became intrigued by the chalk graffiti drawings that formed part of their street culture.

Robert Frank

Robert Frank's photographs of 'The Americans' were initially rejected by the critics, who were judging him by the conventions of the day, but this work has since come to be acknowledged as of seminal importance.

Born 1924, Zurich, Switzerland
Importance Used picture sequences in place of the single image

Robert Frank was born in Switzerland. He took to photography as a diversion from the family's business and made his first photobook, *40 Fotos*, by hand, in 1946. He moved to the US in 1947, where he worked in New York as a fashion photographer for *Harper's Bazaar*. Frank then travelled in Europe and South America, creating another handmade book from work shot in Peru. In 1950, he returned to the States.

He was uncomfortable with the American lifestyle and its materialism and this would be reflected in his work. He moved briefly to Paris, returning in 1953 to shoot for *Vogue*, *Fortune* and *McCall's* magazines. Walker Evans was a major influence and helped him secure a Guggenheim Foundation grant to travel the US and photograph society in all its guises; over a period of two years, Frank took some 28,000 photographs. A book was planned, but his unconventional technique and cropping conspired against finding an American publisher. In 1958, *Les Américains* was published by Robert Delphire in Paris. The reviews were not encouraging, the pictures being described variously as 'sinister', 'perverse' and 'anti-American'. The following year *The Americans* was published in the US, with an introduction by Jack Kerouac, author of *On the Road*, but it was not well received because of Frank's unconventional technique. As Frank put it: 'I was very free with the camera. I didn't think of what would be the correct thing to do; I did what I felt good doing. I was like an action painter.' And despite the initially poor sales, Kerouac's

Robert Frank. His publication, The Americans *(1958), is now considered one of the milestones of photography publishing.*

involvement helped the book reach a wide audience and it went on to inspire later generations of photographers.

Frank concentrated his attention on those rarely seen in the media – African-Americans, teenagers and the elderly. He summed up his rejection of the conventional documentary approach when saying he hated, 'Those god-damned stories with a beginning and an end', typical of what was published in magazines such as *Life*. Instead, he used his talent for sequencing images to tell the story, turning his attention to film-making in the early 1960s. This fed back into his still photography and in 1972, with *The Lines of My Hand*, he began to include words alongside his photographs.

In 1971, Frank moved to Nova Scotia, Canada. His daughter was killed in a plane crash in 1974, and since that time, much of Frank's work has dealt with his loss. The importance of *The Americans* is underlined by its continued referencing by other photographers and, in 2008, a redesigned edition of the work was published to celebrate its 50th anniversary.

Garry Winogrand

Garry Winogrand is prominent among the New York street photographers from the 1960s and 1970s. Although his early inspiration came from notable predecessors, he developed his own style of photographing that became his unique trademark.

Born 1928, New York, United States
Importance Photographed the fleeting network of interactions between the inhabitants of the city's streets
Died 1984, Tijuana, Mexico.

Winogrand studied painting and photography at New York's Columbia University in 1948. He continued to photograph throughout the 1950s, but it was not until the 1960s that he established the personal style for which he became known. In photographing the city streets, he was influenced in particular by the books of two photographers: Walker Evans' *American Photographs* and Robert Frank's *The Americans*. He shot from the hip, often with a tilted lens (like Frank), capturing odd juxtapositions and enigmatic relationships. His first exhibition, in 1960, even mimicked Frank's dark printing style, although he later adopted a lighter touch to make the images unmistakably his own.

Winogrand photographed in the streets, at the airport and at the zoo. His first book, *The Animals* (1969), was shot at the Bronx Zoo, and is as much a study of humankind as it is of the inmates. Winogrand's conception of 'the decisive moment', the currency of the street photographer, often precedes the Cartier-Bresson definition: he captures the instant before something is about to happen. The viewer recognises his photographs are interesting, but cannot always see why.

For his second book, *Public Relations*, published in 1977, Winogrand's project was to 'photograph the effect of the media on events'. For this purpose he shot with flash, just like the newspaper photographers, at a variety of 'photo opportunities' including sports arenas and specially staged parties. While the journalists photographed

the celebrities, Winogrand recorded the event itself, the media at work, and the way in which they and the organisers connived in shaping the news. Images from this series include a Muhammad Ali press conference and the Apollo 11 astronauts.

Winogrand was one of the photographers whose work was championed by John Szarkowski at the Museum of Modern Art (MoMA) and, in 1967, it featured alongside that of Diane Arbus and Lee Friedlander in the MoMA exhibition 'New Documents'. His 'Public Relations' projects had been preceded in 1975 by 'Women are Beautiful', street photographs of New York in which the women in question are pictured unawares, striding purposefully about their business and not necessarily beautiful at all, or even feminine.

Winogrand died prematurely, aged just 56, from gall bladder cancer. His vision and his skill were to recognise and capture the fleeting interactions and relationships that occur spontaneously, often between individuals who will ever only be connected for just that one moment. In doing so, he revealed the way in which we live our lives and brought significance to the mundane.

One of Winogrand's street scenes in New York.

Alfred Stieglitz

Through his founding of an influential gallery, photo journals, the 'Photo-Secession' group, as well as his collaborations with other prominent figures in the medium, Alfred Stieglitz's proselytising elevated photography from a poor relation of painting to an art form in its own right.

Born 1864, New Jersey, United States
Importance Indefatigable champion of photography as artistic expression
Died: 1946, New York, United States

As a teenager, Stieglitz moved to Germany and studied engineering, and then photography, in Berlin. It was in Berlin, in 1883, that he took his first photographs, and he worked in the city for two years as a freelance on magazines. He returned to the US, taking up freelance photography. In 1891, he joined the New York Camera Club and became the first American elected to the Linked Ring, a body formed in 1892 as a pictorialist splinter group of the Royal Photographic Society; this established Stieglitz as the foremost figure in American pictorialism.

He began his association with photo journals in 1893, as co-editor of *American Amateur Photographer*. In 1897, he founded *Camera Notes* and, most notably, in 1903 launched *Camera Work*, a journal that continued until 1917 and published 50 editions.

Stieglitz had a falling out with the National Arts Club, in 1902, over an exhibition he had been asked to curate for the club, and which resulted in his founding the Photo-Secession. The disagreement was between Stieglitz and some of the club's more conservative members, over which photographs should be included. His response was to suggest calling the show: 'American Pictorial Photography Arranged by the Photo-Secession', as in seceding from the accepted idea of what constituted a photograph, and thus the exhibition launched the group. Like the Linked Ring in England, its

purpose was to promote photography as fine art, and the pictorialist style in particular.

Camera Notes was the official journal of the Camera Club and, through it, Stieglitz continued his crusade for pictorial photography. The journal was illustrated with fine gravure reproductions and featured work from Europe as well as the US. Yet, despite all his efforts, Stieglitz again found himself banging his head against the brick wall of the traditionalists and, in 1903, set up his own title, *Camera Work*.

'Two Towers', c.1911. Stieglitz promoted pictorialism – in his words: 'a distinctive medium of individual expression'.

In partnership with Edward Steichen he opened the Little Galleries of the Photo-Secession at 291 Fifth Avenue in 1905, soon to become known simply as '291'. The gallery showed contemporary photography alongside modern art, bringing the European avant-garde to New York with work from Matisse, Picasso, Braque, Cezanne, Rodin, Brancusi and others. In 1916, Stieglitz began photographing the painter Georgia O'Keefe and, over 20 years, built a body of work comprising some 300 portraits.

Although a talented photographer, the most important contribution Stieglitz made to the medium was in its promotion as a valid art form. He was an artist who chose the photograph as his personal medium of expression, and spent a long career preaching to the unconverted.

PHOTOGRAPHY AS ART

When the French artist, Eugène Delacroix, famously exclaimed that 'From today, painting is dead', he implied that the new photography, in this case a daguerreotype, was an art form, and rather better at the job than a pencil or a paintbrush. In fact, at this time, any form of reproduction was accepted as art, and so that was that.

Painting didn't die, of course, but photography did few favours to painters who relied on portrait commissions. However, it wasn't long before photography's credentials were questioned: could it really be considered art without being elevated by the creative hand of the artist? It quickly came to be seen as a process that simply copied, and those that practised it for gain, merely tradesmen.

Some early photographers *were* artists, among them former painters, and plenty more who had taken up the medium with artistic aspirations. For them, the challenge came to be the making of photographs that didn't look like photography, perhaps more like painting. In order to produce picturesque effects, they began to experiment by intervening in the print-making process: replacing the photographic image with lithographic ink (the bromoil process) or carbon, to produce an image that was aesthetically pleasing, yet had lost most of the clinical reality of the original. Another example was the gum bichromate process. But although on one level this did the job, on another it seemed an admission that photography really was rather second-rate. So the search was on for a way in which the *taking* of the photograph rendered it more artistic.

Photography split into two camps: the 'painterists' aiming to make photographs that looked like paintings, by any form of intervention or process necessary; and the purists taking the opposing view in wanting to shed photography's dependence on painting and

rely purely on light to create expression. In the early-twentieth century Alfred Stieglitz and others formed the Photo-Secession group, believing photography's importance to be its intimate relationship with reality. Impressionistic, artistic photographs could be made without resort to artificial aids, and remain true photographs. The emphasis was more on the subject than how it was rendered.

The march of true photography toward validity as an art form continued, moving further away from a desire to imitate painting. Photographers had always tended to form groups for mutual support and development, and would regularly exhibit their members' work. A hint that photography was beginning to be thought worthy of consideration as art came when major museums and galleries of fine art began to include it in their programmes. When photographs began to sell at auction for prices on a par with paintings, it could no longer be suggested that photography was an inferior medium.

'I was meticulously copying other art and then I realised I could just use a camera and put my time into an idea instead.'

Cindy Sherman

In 1999, 'The Great Wave, Sète' by Gustave Le Gray, made in around 1857, fetched over half a million pounds at auction: this beat the previous record for a single photograph, held by another Le Gray print from the same sale, earlier that day. Since the turn of the century, contemporary photographers have joined the 'old masters' in the price league table, notably Andreas Gursky whose '99 Cent II Diptychon' fetched £1.7 million ($3.35m) at Sotheby's in 2007, the most expensive photograph ever at the time of writing.

Recent trends in art photography include print enlargement to enormous size, a nod in the direction of the painted canvas, and the embracing of documentary imagery whose original purpose was to prick the collective consciousness – an acknowledgement that photography has always been art in the hands of an artist.

Edward Steichen

Along with his collaborator, Alfred Stieglitz, Edward Steichen was a major force in the evolution of the photographic medium throughout the first half of the twentieth century, and created one of the most ambitious and important exhibitions of all time, 'The Family of Man'.

Born 1879, Luxembourg
Importance Influential promoter of photography as art
Died 1973, Connecticut, United States

When Steichen (born Eduard) was two, his family emigrated from Europe to the US. As a teenager, he studied art in Milwaukee and, in 1894, became an apprentice lithographer, during which time he was both painting and making photographs. He was a self-taught photographer and worked in the pictorialist style, using considerable darkroom manipulation to create dramatic, painterly prints. During the 1890s, he submitted work to many pictorialist salons and came to know Alfred Stieglitz. Like Stieglitz he became a member of London's Linked Ring and worked with him in founding the Photo-Secession. He also worked on *Camera Work* magazine.

After the First World War, Steichen adopted a 'straight' modern style that took him away from pictorialism. His change in approach involved a simpler printing technique, photographing in the style of the symbolist art movement, making landscapes, cityscapes and portraits of the rich and famous in both Paris and New York. Between 1923 and 1938 he was chief photographer at publishers Condé Nast, working on *Vogue* and *Vanity Fair*. During this period he freelanced in the infant genre of advertising photography.

By 1938, he found this commercial work no longer stimulating. He also thought that the resistance to fresh ideas in photography that had inspired the founding of the Photo-Secession was falling away, and that the success of the great picture magazines, such as *Life*, and the work they initiated, had erased the aesthetic distinctions between

Chamorro girls from Guam, photographed by Steichen in 1945.

photography and art (see also, page 114). During the Second World War, he served as director of the US Naval Photographic Institute and curated two exhibitions of photography at the Museum of Modern Art (MoMA), becoming director of photography in 1947.

It was here that Steichen would make his greatest contribution to photography and its promotion as an art form. During his tenure, he organised more than 45 exhibitions at MoMA, among them the most ambitious and important of all time, 'The Family of Man', in 1955.

This exhibition was considered by Steichen, and the majority of commentators, as the culmination of his career. 'The Family of Man' comprised over 500 photographs by 273 photographers, portraying life in 68 countries around the world. They were selected from almost two million submissions by established and unknown photographers. The exhibition catalogue is still in print and has sold over four million copies. Some nine million people viewed the show on its world tour.

Steichen retired in 1962 at the age of 83. His influences on photography had been two-fold: first his promotion of pictorialism through collaboration with Alfred Stieglitz and, second, in creating the most popular photography exhibition ever staged.

Man Ray

In the history of photography, the early-twentieth century is a fertile period. It was a time when many important figures experimented with new techniques and subjects in a way that would see the medium grow into the ubiquitous means of visual communication and artistic expression it is today. One such innovator was Man Ray.

Born 1890, Philadelphia, United States
Importance An artist better known for manipulating light than paint
Died 1976, Paris, France

Man Ray's Russian-Jewish parents changed their surname to a Westernised version when he was young, in response to the anti-Semitism prevalent at the time. Born Emmanuel Rudnitsky, when his brother chose the family name of Ray, he adopted the first name Man from his nickname Manny. He studied art in New York and aspired to become a painter. Ray discovered photography at the 291 Gallery of Alfred Stieglitz and bought his first camera in 1915, initially to photograph his own paintings. These early years were spent painting and drawing. He became friends with artist Marcel Duchamp and began to follow the anti-art Dada movement. One of the fields they explored was 'readymades': an everyday object taken by the artist is then, maybe with some modification, presented as a work of art. A well-known example by Ray is 'Gift', a flat iron converted to a paradox by attaching nails to its base. He began to make his first significant photographs in 1918.

Ray moved to Paris in 1921 and settled in the artistic quarter of Montparnasse. He became a fashion photographer for *Vogue* and began the darkroom experiments that became an important part of his style: the first of these he called 'rayographs', commonly known as photograms. The technique involves placing an object on photographic paper and exposing it to light, so producing a negative

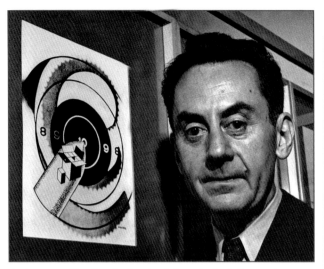

An innovator, Man Ray developed techniques in the dark room that became synonymous with his style.

version of the object which, if translucent, imparts interesting tonal effects to the print. In 1922 he opened a photographic studio, which was an immediate success and he made portraits of the writers and artists in whose circles he moved. Some of his most famous photographs – 'Ingres' Violin' (1924), and 'Black and White' (1926) – reveal a move towards surrealism and he was to become considered as the in-house photographer for the movement.

In 1929, Ray began a love affair with surrealist photographer Lee Miller and she became his assistant. Back in the darkroom, they rediscovered the process of solarisation. The process involves re-exposing a negative or print to light during processing, so causing partial reversal of the tones. Solarisation was employed by Ray in many of his portraits and nude studies and this made him famous.

Man Ray was an artist who used photography as a medium of expression. Through his involvement with the art movements of the day, and his experimentation and collaborations, he made a major contribution to photography as an art form.

New Vision

László Moholy-Nagy

László Moholy-Nagy was an artist who never quite settled down. He followed many of the avant-garde European art movements between the two world wars without siding with any particular one, and in this respect he was an original. He was central to the New Vision movement – a term he coined himself – in Europe during the interwar years, a way of artistically expressing a new way of seeing, not possible with the eye. This lead to his many experiments with light and to photography, although initially he didn't use a camera.

Born 1895, Bácsborsód, Hungary
Importance Introduced the concepts of the Bauhaus and European avant-garde to the US
Died 1946, Chicago, United States

Moholy-Nagy was born László Weisz. He changed his Jewish surname to that of his uncle, Nagy, later adding Moholy in reference to the town he grew up in, Mol. He studied law at the University of Budapest, leaving at the outbreak of the First World War to serve in the Austro-Hungarian army. Wounded on the Russian Front in 1915, he began drawing while recovering in hospital. After the war, rather than returning to his studies he decided to pursue a career in painting, moving to Berlin in 1920.

In 1923, he joined the staff of the renowned Bauhaus in Weimar, where he was head of the metal workshop and taught on the foundation course. The great influence of the Bauhaus on design, industry and the arts was a result of the polymath talents of those who taught there, and Moholgy-Nagy was no exception. Since 1922, he had exhibited his paintings and sculptures, and he was to work in film, typography and photography.

He had begun experimenting in photography just before joining the Bauhaus. This early work, still considered among his most important, comprised photograms. It was around the same time as

Man Ray was also experimenting with this form of camera-less photography, where negative images of objects placed on photographic paper are created by exposure to light. Moholy-Nagy's work differed from that of Ray in the way he was experimenting with the play of light, rather than the imprint of the objects themselves. This work remained at the core of his photography for 20 years, many of the images incorporating self-portraits into their structure.

'Boats, Marseille', taken by Moholy-Nagy in 1927. The image has a graphic quality seen in much of his work from this period.

Moholy-Nagy left the Bauhaus in 1928 and returned to Berlin. Here, he showed almost 100 photographs and photograms in the exhibition 'Film und Foto', and he stayed in the city for six years working as a set and exhibition designer, and making films. He moved to Amsterdam in 1934 and then London the following year. In 1937 he moved to Chicago to become head of the New Bauhaus American School of Design. In 1939 he founded his own school of design, which, in 1944, became the Chicago Institute of Design.

László Moholy-Nagy and his Bauhaus colleagues led the generation of exiled Europeans that, through its dissemination of avant-garde concepts, had a profound influence on American artists. Photography was just one aspect of his art; but his fascination with light, which he translated into print, is of abiding significance.

Alexander Rodchenko

Alexander Rodchenko was a constructivist who came to photography through art and graphic design. He constantly experimented with new ways of revealing what things were and developed a photographic style attuned to the brave new world of post-revolutionary Russia and the age of mechanisation.

Born 1891, St Petersburg, Russia
Importance An artist-photographer with a particular influence on twentieth-century graphic design
Died 1956, Moscow, Soviet Union

Rodchenko's family moved to Kazan in 1909, but he moved to Moscow and the Stroganov School of Applied Arts in 1914. He became prominent among the Russian avant-garde as a painter and sculptor, and in particular as a graphic artist designing posters, book covers and illustrations, even furniture. His early involvement with photography began in 1922 with experiments in photomontage in relation to his poster and book design and, in 1924, he began to use a plate camera to produce his own photographic raw material for the work.

He came to photography from design, believing the camera to represent the medium of the day. He took up the compact Leica 35mm camera, which allowed him to observe from all kinds of unconventional viewpoints, as might the natural human eye, instead of a commonplace navel-height perspective.

By 1926, photography had become his primary artistic medium, employing unfamiliar high and low viewpoints and unusual perspectives. He photographed the movements of processions and sports events, and developed a style of incorporating the line, working structures such as stairs and overhead cables into his compositions.

In 1930, he had been a founding member of the important October group of photographic and cinematographic artists, only to be expelled the following year on charges of 'formalism'. This was most

unfortunate for an artist who had put all his talents behind the ideals of the Revolution; they seemed to be accusing him of having too much taste. 1933 saw the introduction of a law which made photography in Moscow subject to authorisation, and this inevitably limited his scope; the same year Rodchenko and his wife, artist Varvara Stepanova, founded the magazine *SSSR na stroike* (*USSR Under Construction*) for which he photographed until 1941. Its subject matter was particularly well suited to his style,

Rodchenko's cover design for a book by Russian poet Vladimir Mayakovsky.

wherein the building and the builders took on a heroic scale. His photographs captured and portrayed the activities, hopes, and aspirations of the new Soviet life.

He was rehabilitated with the October group in 1935 and participated in the 'Masters of Soviet Photo Art' exhibition in Moscow. He returned to painting in the late 1930s and stopped photographing in 1942, save for some experiments with early colour photography.

Alexander Rodchecko introduced a style of photography attuned to the avant-garde movements of the day and, in doing so, was instrumental in easing the medium's passage into the world of art, while retaining a clear sense of photography's own particular qualities.

André Kertész

André Kertész was the master of the ephemeral moment, the overlooked detail. His pictures captured the beauty of life and have been a source of inspiration for successive generations of photographers.

Born 1894, Budapest, Hungary
Importance An inspiration to other photographic greats
Died 1985, New York, United States

Kertész took up photography as a hobby while working at the Budapest Stock Exchange. He taught himself how to develop and print his own film, but his interest was in artistic expression rather than the technical side of the medium. He had success as an amateur, winning a self-portrait prize in 1916, and the following year a dozen of his pictures were reproduced as postcards and his work published in the magazine *Érdekes Újság*.

After serving in the Austro-Hungarian army during the First World War, where he was wounded in 1915, he returned to the Stock Exchange until moving to Paris in 1925. He settled in the artists' quarter of Montparnasse where he mixed among the avant-garde and began to take photographs of the cafes, street scenes and Paris gardens, as well as making portraits of the artists he met.

Kertész worked as a freelance during his 12 years in Paris, his work appearing in major newspapers and magazines in London, Germany and Italy, as well as France. He was not entirely comfortable with photojournalism, however: 'They want documents, technique, not expressive photographs', as he put it. His first solo exhibition was held in Paris, in 1927, at the avant-garde gallery Le Sacre du Printemps, and in the following years his work was exhibited widely, over 40 shows all told, including landmark exhibitions such as 'Film und Foto' (Stuttgart, 1929) and 'Modern European Photography' in New York, in 1932. At the latter his 'proofs' were priced at $20 apiece: a substantial price in Depression-hit America.

In 1933, he created what would later become an important body of work. His 'Distortion' series comprised 200 shots of two nude female models photographed using a distorting mirror, so distorting, in fact, that in some of the pictures it is hard to make out what is being shown. Some of the work appeared in magazines that year, but a book featuring the full series did not appear until 1976.

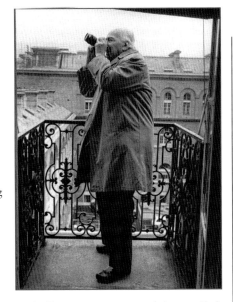

André Kertész, on an apartment balcony on Ile de la Cité, 1982.

He was a friend and mentor to several eminent photographers, including Cartier-Bresson and Brassaï, who he met in Paris. In 1936, he was invited to New York by the director of the Keystone Agency and was given a contract. However, Kertész was not happy and, with the Second World War preventing his return to Paris, he left the agency the following year and took magazine commissions from *Harper's Bazaar*, *Town and Country*, *Life*, *Vogue* and *Look*, photographing fashion and interiors. Classified as an enemy alien during the war, he was prohibited from working; he finally became an American citizen in 1944.

Although André Kertész personally felt that he had always been undervalued, his work is among the most commonly cited as inspirational by other photographers. As Henri Cartier-Bresson once said, 'We all owe him a great deal.'

Cindy Sherman

Having decided that the camera, rather than the paintbrush, was the best medium through which to express her ideas, artist Cindy Sherman set about exploring the contemporary and historical representation of women in film, television, photography and art.

Born 1954, New Jersey, United States
Importance Highly influential conceptual artist working with staged photography

Cindy Sherman is one of several artists who independently, in the 1980s, began to adopt photography as their medium of expression. She studied painting and photography at university in Buffalo, graduating in 1976 and working in the nearby Hallwalls Gallery. She held her first solo exhibition there in 1979. During her time at university she abandoned painting in favour of photography.

After graduation Sherman moved to New York, where between 1977 and 1980 she created her landmark series of sixty-nine 'Untitled Film Stills', shown at the Metro Pictures Gallery, in New York, in 1980. Photographing in small-format black and white she posed herself as an actress in an American B movie, or television series, in a body of work that explored the image of women as portrayed by the media in what amounted to a series of male fantasies. Although each image is, in effect, a self-portrait, the work bears no resemblance to portraiture; in each she is acting out a role as dictated by the cultural perception of women in society. The series succeeds because each image works exactly as it sets out to: each is entirely convincing as a film still and invites the viewer to imagine the storyline and the lone heroine's role within it. They work simply because Sherman is always on the button and she judged the series to be complete when, as she has said, she 'ran out of clichés'. The work has launched a thousand student theses and contributed to the debate surrounding photographic representation and gender politics. The entire 'Untitled

Cindy Sherman's 'Untitled (#70)' taken in 1980.

Film Stills' series was acquired by the New York Museum of Modern Art (MoMA) in 1995.

Although this remains her most important work to date, Sherman has continued to develop the concept, moving into colour and photographing in larger formats. Among the themes she has explored are parodies of painted portraits, fashion photography and centrefolds, dreams and nightmares, and soft-core pornography. Success having come early to her, Sherman has had the opportunity to work in other genres, designer fashion photography and album covers among them. She has worked as a film director: her first film, *Office Killer*, was released in 1997, and she has taken cameo roles in pop videos and film.

Cindy Sherman continues to be an artist of international significance, although her early work remains, for the time being, her most important. 'Untitled Film Stills' made her one of the most important photographic artists of the late-twentieth century..

Index